Horse Mania

A Public Art Project of the Lexington Arts & Cultural Council

Photographs by
Mary S. Rezny

Text and Captions by
L. Edward Purcell

Acknowledgments

As with any project of this magnitude, it takes many wonderful volunteers to be successful. To that end, the board of the Lexington Arts & Culture Council wishes to acknowledge the following individuals for their extrodinary support of Horse Mania: Steve Duvall and Jeff Masters for designing, manufacturing, and giving us the concrete pallets on which the horses were mounted; Jim Wilhite for his invaluable help in placing the seventy-nine concrete pallets in their various locations in Lexington; to the many construction company volunteers who in an unbelievable two and a half hours had all seventy-nine of the horses mounted on their pallets; and to David Switzer for his help and early understanding of the significance of this art project to Lexington and the thoroughbred industry. Furthermore, we would like to recognize three members of the steering committee whose efforts over the last eighteen months made this project a reality: Dee Fizdale, Executive Director of the LACC, for her vision as well as her invaluable experience, knowledge, unwavering optimism, and support; Becky Reinhold for her neverending efforts in procuring sponsors, contributors, and coordinating all of our special events; and to Steve Grossman for his consistent leadership, hard work, and unbounded enthusiasm in all aspects of this great public art project.

Additionally, we want to recognize the executive committee of the LACC for their decision to bring Horse Mania to Lexington, especially to Janet Craig our current Chair for her time, energy, and legal counsel during this project and to Melissa Wasson for wonderful assistance with our Horse Mania auction. Also, we want to thank David Lord for his generous assistance and advice; Mary Wathen for naming the project; Mike Whitehouse for tireless assistance with printing; Georgann Chenault for her design and donation of our Horse Mania logo; and to the staff of the LACC whose support was invaluable.

Lexington Arts & Cultural Council
ArtsPlace
161 North Mill Street
Lexington, Kentucky 40507

ISBN 0-9704943-0-0

Book design and layout by L. Edward Purcell (Lexington Associates)
Digital color separations by Kentucky Pre-Press, Inc.
Electronic page makeup by Christopher Bandy (*asterisk)
Copyediting by David F. Burg
Manufacturing by Image Graphics, Incorporated
Horse Mania logo by Georgann Chenault (Chenault Design)

Contents

Crazy for Art

If you asked anyone in Lexington, Kentucky, during the summer of 2000 about "the horses," they knew exactly what you meant.

There was no confusion with the multimillion-dollar yearlings going under the hammer at the Keeneland July Select Sale or the horses that high stepped in the arena at the Junior League Horse Show or the thousands of horses gamboling in the fields of the surrounding farms.

No . . . "the horses" meant the painted, decorated, and embellished horses of Horse Mania, the public art project of the Lexington Arts & Cultural Council, which overnight turned Lexington into a city bursting with art fans.

Throughout the nearly five months of the horse exhibit (from late June to mid-November), the public admired, touched, and photographed the statues. You could hear conversations about the horses wherever you went in Lexington during the summer of 2000, as opinions and insights about favorite horses were shared by the thousands.

As the arts columnist for the *Lexington Herald-Leader* noted: ". . . Lexington was oohing and ahhing over Horse Mania." People could be seen every day with guide maps and cameras in hand, wandering among the heavy concentration of downtown horses or setting out to tour all seventy-nine horses, usually making certain to get a picture of themselves with their favorites.

The immense public impact of Horse Mania surprised even those who had dreamed up the project and worked hard to make it happen.

After Lexington Arts & Cultural Council board member Janet Craig returned from a summer 1999 trip to Chicago and told others on the board about that city's popular "Cows on Parade" and suggested the LACC do a public art project based on horses, the group moved quickly to set Horse Mania in motion.

The LACC formed a committee headed by 1999–2000 chairman Steve Grossman, and with the help of executive director Dee Fizdale and her staff, by March sponsors for the horses were on board and artists had been selected. In late June, the finished horses were placed on their concrete pallets, unleashing the overwhelming response.

During the summer and fall months, people flocked to the horses, and they stopped to view, to touch, to discuss, and to appreciate. As one observer said: ". . . people could not resist stroking the bodies, admiring the artistry, and posing for pictures."

Horse Mania made touring public art a family affair.

It seemed as though almost everyone brought their cameras.

Many people followed the Horse Mania trail with maps in hand.

This was truly public art, realized in a way seldom seen and with a broad appeal to all ages and social strata. Because of their locations out-doors, unlike art in a museum, Lexington's horses were uniquely accessi-ble to anyone and everyone. In some cases the meaning of the art was obvious to even the youngest and least sophisticated viewer; in other cases it took a background in art history and a lot of looking (and, per-haps, touching) to understand the artist's message. But in all cases, there were no barriers between Horse Mania and the public: it was all close up and immediate.

A good deal of the public fascination could doubtless be traced to the natural elegance of the thoroughbred, a three-dimensional form created by Nature that was a great starting point for whatever embellishments or expressions the artists had in mind. (One observer noted that the univer-sal reaction of wanting to touch the Horse Mania statutes was probably related to the strong impulse to pet a real, live horse.)

It was astonishing to see the diversity and variety the artists came up with. For example, somewhere among the seventy-nine horses, you could see nearly the full range of artistic media: painting, ceramics, sculpture, collage, mosaic, metal casting, applique, and more.

Likewise, the horses showed an extreme range and variation of con-cept: some were straightforward and uncomplicated; others were abstract; a few were profound. Deeply personal artistic statements existed side by side with delicious whimsicality, homage to the masters, political awareness, cross-cultural sensitivity, virtuoso displays of sheer technique, and straight-out commercial promotion.

Some of the horses revealed their meaning and charm from a dis-tance (even from a passing car), but many required the sort of close-up inspection the public seemed to favor. Some horses expressed a single simple idea, while others dealt with dozens of ideas in complex ways. Some of the horse art was big and bold; some was delicate and executed in miniature.

Horse Mania culminated in early December, when the horses were auctioned off to benefit charities selected by the sponsors and to benefit a fund for future public art projects.

Following is a photographic tour of Horse Mania, beginning with the cluster of downtown horses (nearly half of the total were grouped within a few blocks along Vine and Main Streets and Broadway), then moving slightly away from the business center to the art horses that appeared to be grazing along city streets, and ending with the outriding horses along the city's perimeter.

Enjoy!

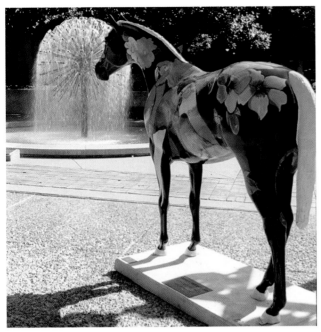

The horses enhanced their surroundings with vivid colors, forms, and textures.

When the public met the horses, the almost universal reaction was laughter and smiles.

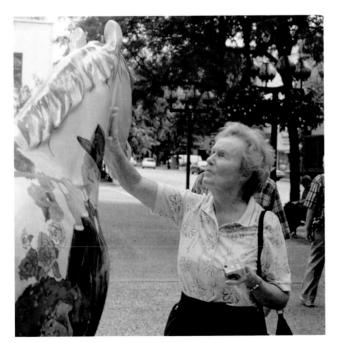

Few could resist the impulse to touch the horses.

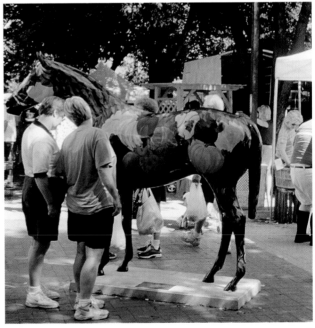

"Vegetariat," located in the middle of Lexington's Farmers' Market, was a hit with produce shoppers.

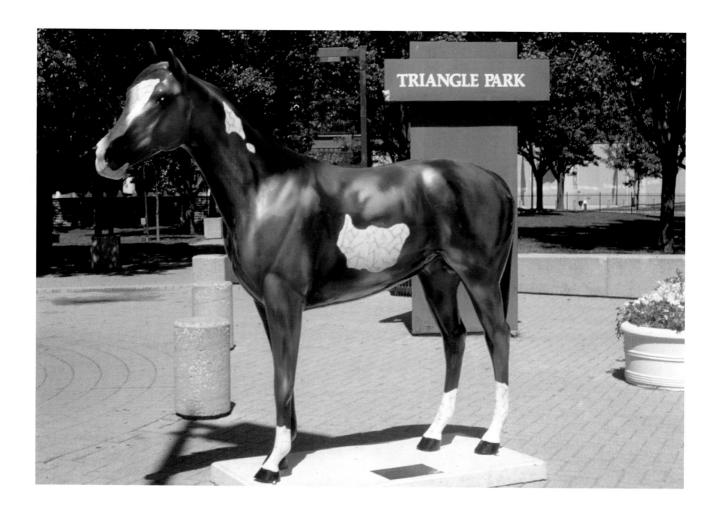

Raku Horse by Ohio ceramic artist Melinda Ishida-Forster occupied one of the high traffic spots in the city: Triangle Park at the corner of Main and Broadway streets. It was touched and admired by dozens, if not hundreds, of passersby every day. The surface of the horse was finished in a startlingly accurate mimicry of the beautiful surface of raku pottery, giving the impression that the horse had been fired in a high-temperature kiln. The Clay-Ingels Company sponsored the horse.

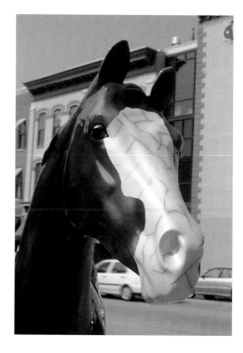

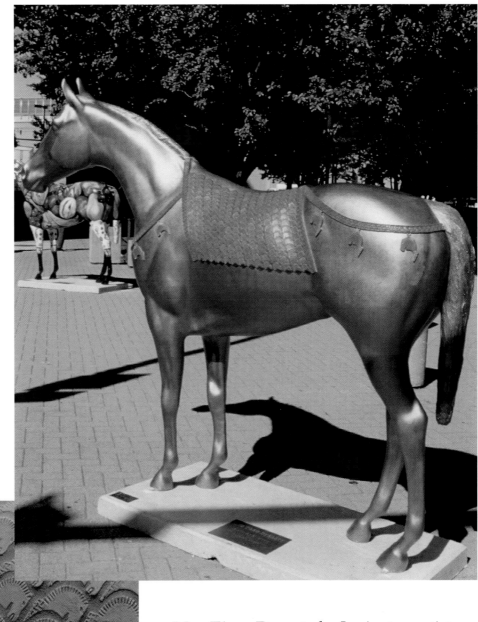

Mus T'ang Dynasty by Lexington artist Kathryn Wise, a clay relief sculptor, paid homage to the tradition of Chinese horse art. To make the horse's blanket, she carved and painted hundreds of clay tiles in the form of stylized horse heads. The horse stood in Triangle Park across from the offices of sponsor Hilliard Lyons.

Galloping Gourmet, one of two horses painted by Lexington artist Nancy Evans Nardiello (see also "Katfandu," p. 63), added a feast of food images to Triangle Park. Giant fruits and vegetables wrapped around the horse, while the head and legs formed a blue and white bowl. Shawnee Farm was the sponsor.

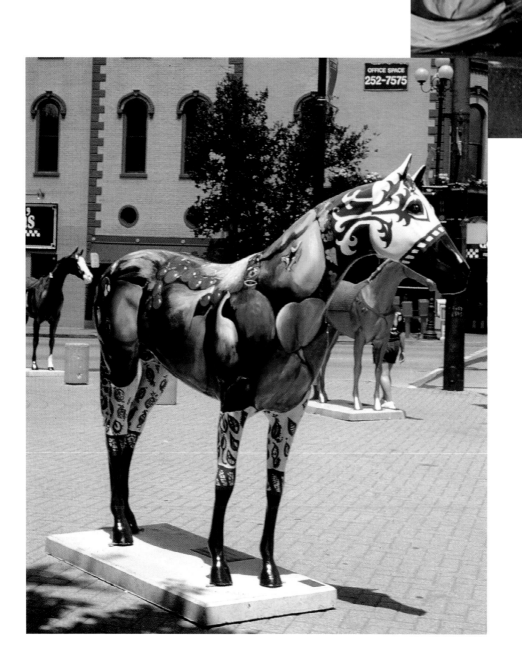

Chard-de-neigh by Lexington artist and gallery owner Gayle Cerlan was a mosaic of colorful china shards, including bits and pieces of tea cups, saucers, and plates. Standing on a busy downtown corner of Triangle Park, the horse with its clever name attracted lots of attention from pedestrians. Jonabell Farm was the sponsor.

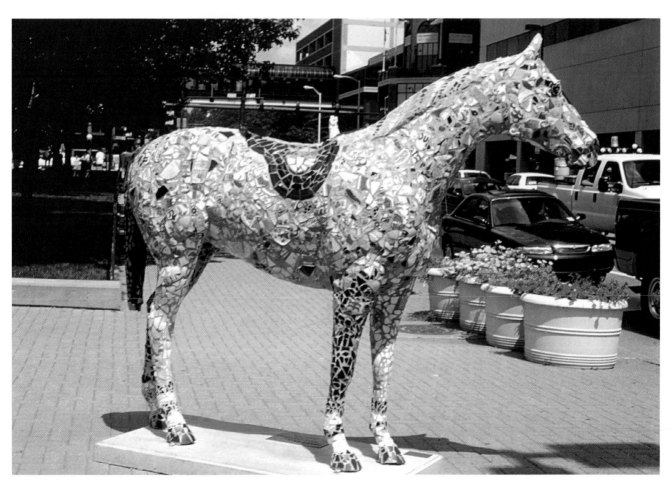

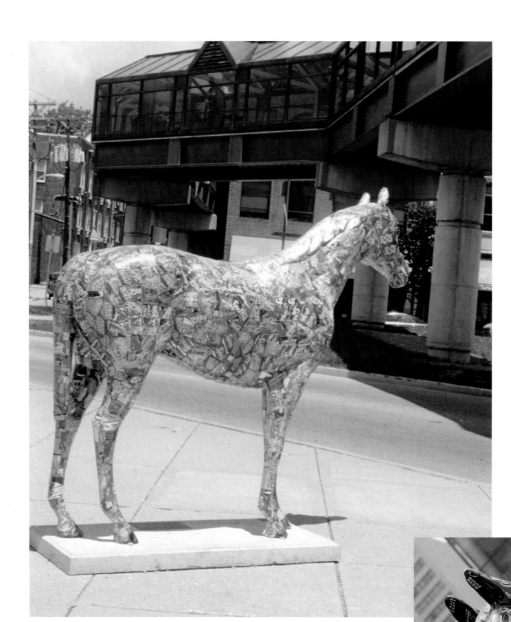

Can O War, was a mosaic horse, covered by flattened soft drink cans (Pepsi, Double Cola, Dr. Pepper, Welch's Grape Drink, etc.). Lexington artist and former teacher Robert Love often creates mosaics with empty aluminum cans. Viewers saw the horse, which was sponsored by KBC International, in front of the lower entrance of the Lexington Center.

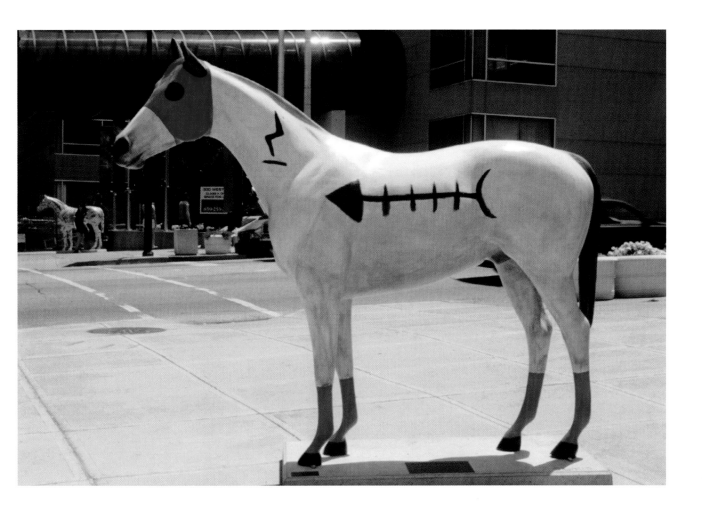

Battlehorse, by Chris Sullivan, starkly suggested the decoration and symbolism of a Native American war horse. It was prominently displayed on the busy corner of Vine Street and Broadway, where convention goers, tourists, and local people passed by in the thousands. Middlebrook Farm and Helen Alexander were the sponsors.

Future Flowers on Vine Street and Broadway was the creation of Wilmore, Kentucky, artist Michael Goodlett, who imagined a dreamscape with highly colored, surreal vegetation and flowers growing up into a blue sky. Tenmast Software sponsored the horse.

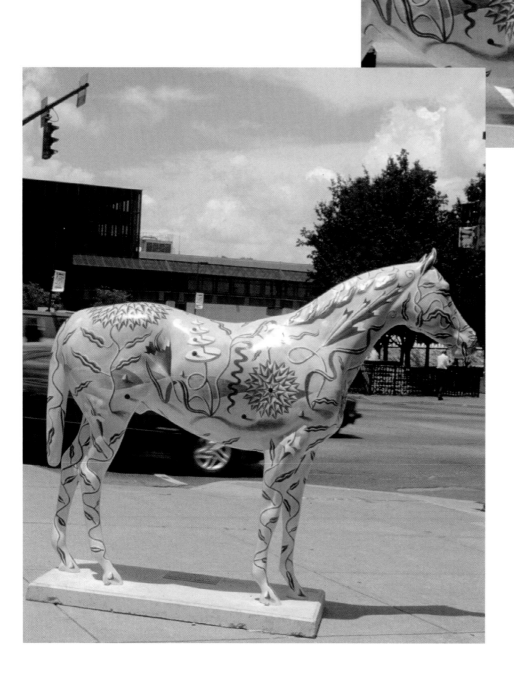

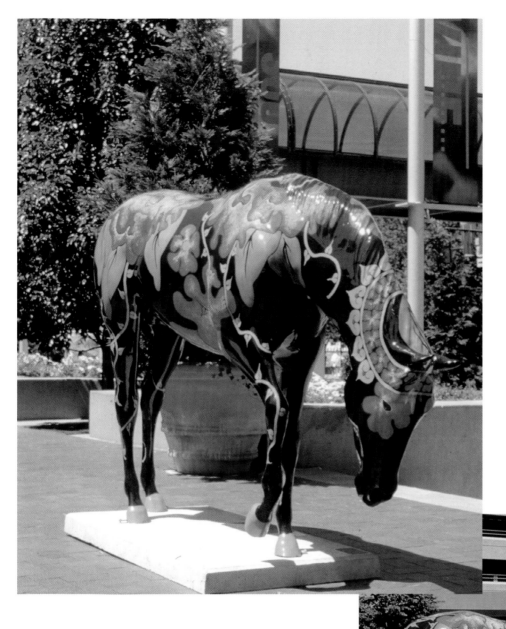

Gerania by Lexington artist Diane Sparks Forrester was a riot of colorful painted flowers and vines on a black background and was one of several art horses near the corner of Vine Street and Broadway. The sponsors were Langley Properties, Central Bank & Trust Company, and Fowler, Measle & Bell.

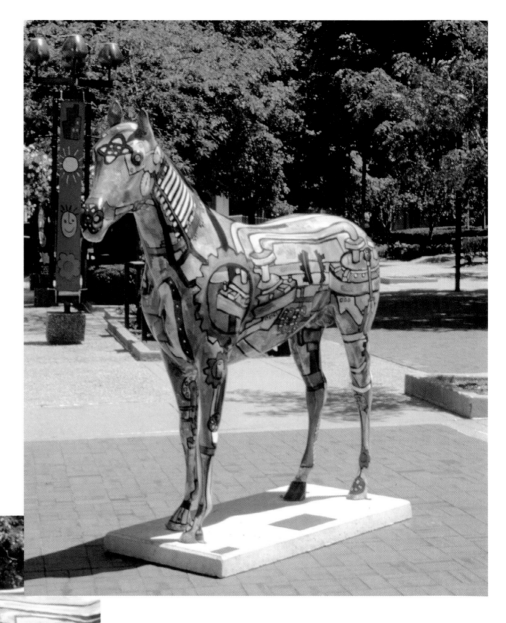

Distillery featured scenes from the sponsor Bulleit Distilling Company, which was previously owned by the family of the artist, Anne Hollister Bulleit. Located at Mill and Vine Streets in downtown, the horse's colorful images depicted the intricate plumbing and machinery characteristic of the distilling plant.

Starry Night was artist Bettye Brookfield's homage to the nineteenth century Dutch painter Vincent Van Gogh. Brookfield, who teaches art at St. Catharine College in Springfield, Kentucky, used images and forms from one of Van Gogh's most famous paintings (of the same name). Located at Mill and Vine Streets, it was sponsored by PNC Bank.

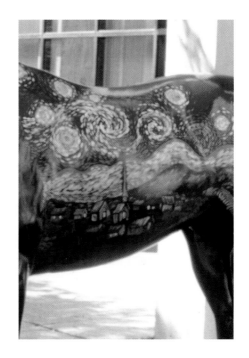

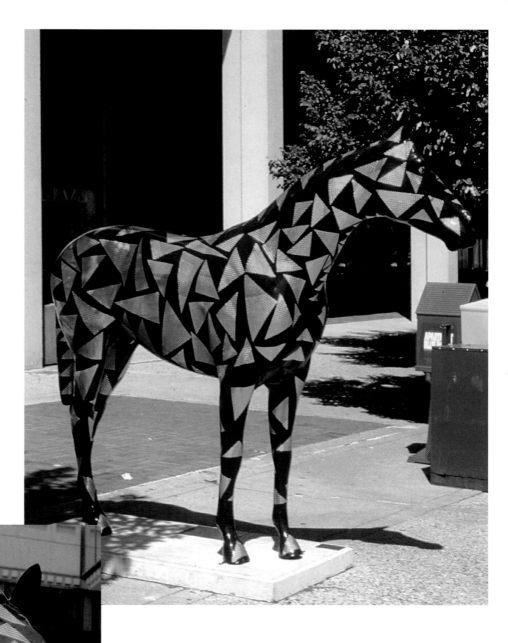

Sparkle by Lexington fiber artist and University of Kentucky teacher Arturo Alonzo Sandoval grabbed the viewer's attention with multi-colored, highly reflective, holographic triangles on a stark, black background. It was hard to ignore, even when motoring rapidly by its location on Vine Street at North Upper. Regency Financial LLC and LexCin Partners were the sponsors.

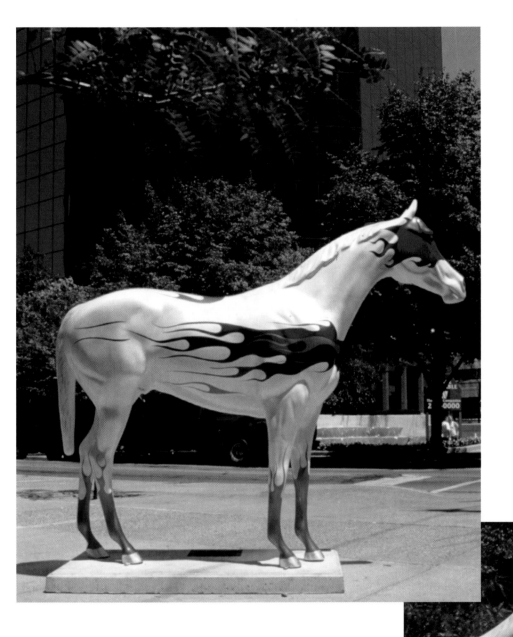

Orion was executed by body shop owner Steve Green, who incorporated into the design the sort of "flame job" familiar to custom car enthusiasts. The horse also was a bow to the rare white thoroughbred race horse bred by sponsor Patchen Wilkes Farm. The horse was located at West Vine and Mill streets.

Crossing on Faith by Cynthiana, Kentucky, artist Ben Mansur, who teaches at Eastern Kentucky University, drew on a rural scene from his family history. The horse was elevated on a trestle platform in front of sponsor Fifth Third Bank's building on Vine Street. A violent thunderstorm in August swept through downtown and damaged the horse, but it was subsequently repaired and restored to its stand.

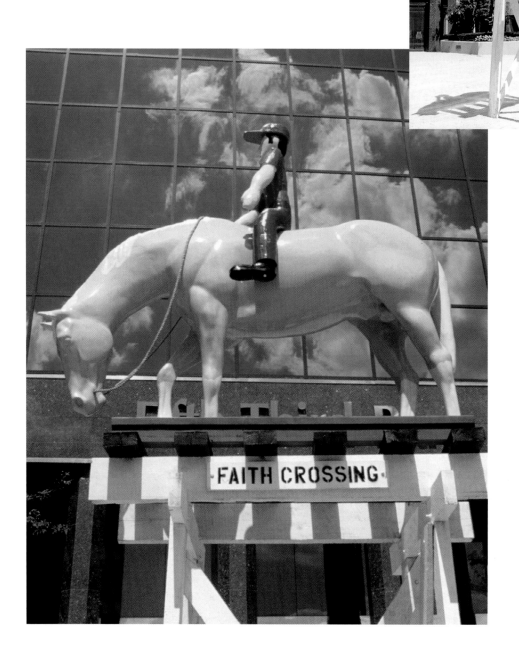

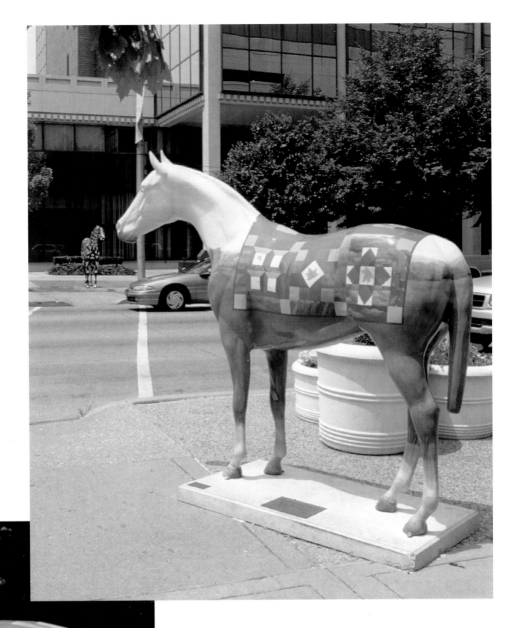

Pieces of Bluegrass, a downtown horse by Marge Adkins of Florence, Kentucky, featured a soft, subtle landscape background and patchwork quilt with stone fence and leaf panels as a saddle blanket. It was at the corner of North Upper and Main streets. The color scheme was in soothing blues and greens. Wyatt, Tarrant & Combs was the sponsor.

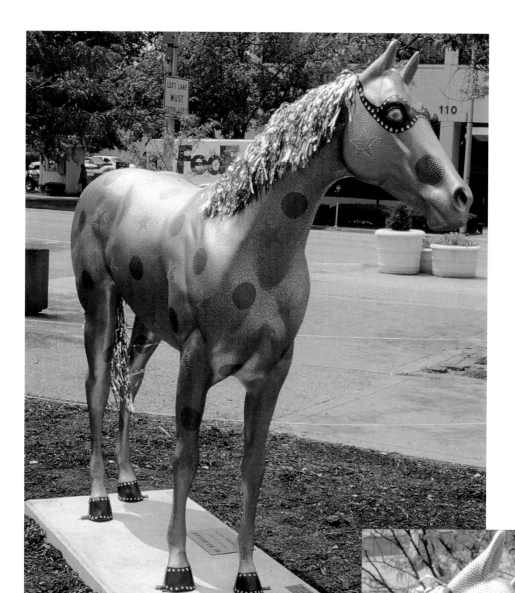

Hi Ho Silver by Blake Eames made the Lone Ranger's TV horse look pale and plain by comparison. The art horse, located in front of sponsor Joe Rosenberg Jewelers' store on the corner of North Upper and Vine Streets, stood out brilliantly with a metallic background, tens of thousands of decorative dots, and silver tinsel mane and tail.

Vegetariat by Lexington artist Molly Costich Wilson featured giant painted fruits and vegetables amidst green leaves (complete with crawling lady bugs). It was located most appropriately on Vine Street in the middle of the site of the weekly Saturday morning Farmers' Market. Dean Dorton & Ford was the sponsor.

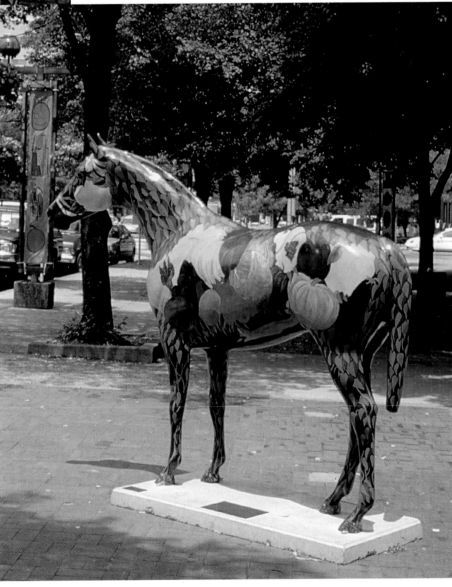

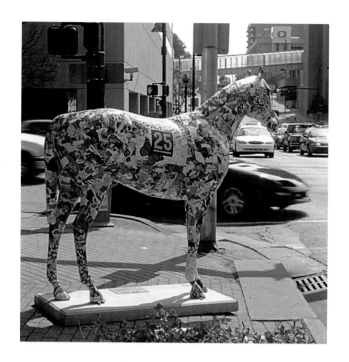

Mr. Ad was a collage of hundreds of print ads from co-sponsor Meridian Communications. Meridian's art director Suzanne Nunnelley headed an eight-person advertising agency team that selected the ads and then decoupaged them onto the surface of the horse. It was located on the corner of Broadway and Main, in front of the Triangle Center building. Three Chimneys Farm was the co-sponsor.

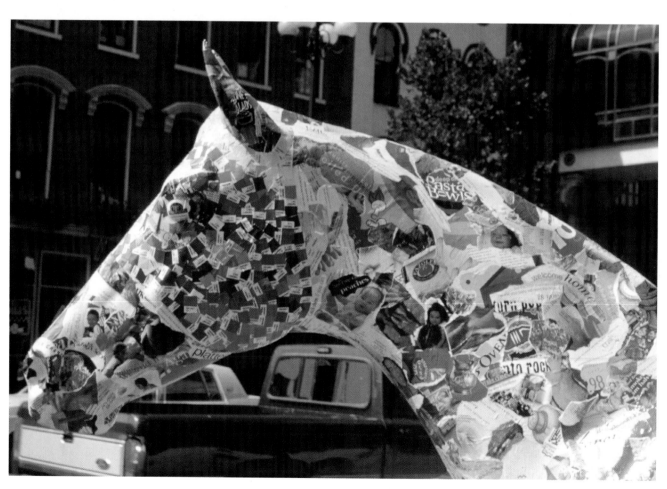

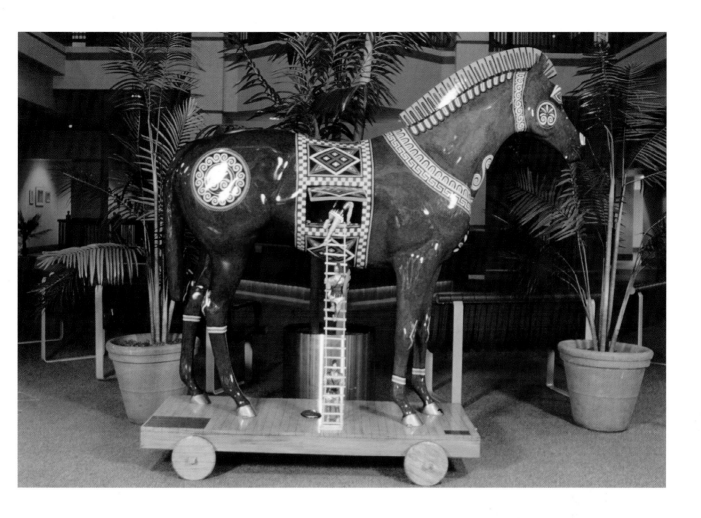

Trojan Horse by Indiana artist Earl G. Snellenberger was an elaborate re-creation of the ancient Greek story of the Trojan Horse, a subterfuge by which the Greek warriors hid inside a giant wooden horse. Snellenberger altered the basic Horse Mania form to resemble a Greek statue and created detailed armed warriors climbing into the horse's belly. The horse was displayed in the lobby of the Triangle Center and was sponsored by Mill Ridge Farm.

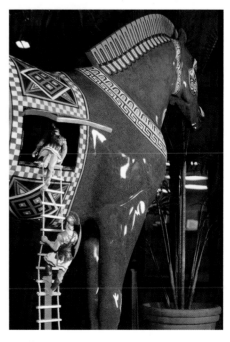

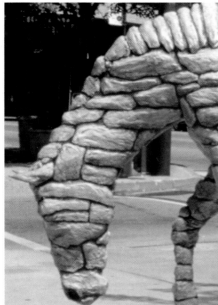

Stonewall by Damon Farmer combined two of the dominant features of the Bluegrass landscape: horses and hand-built stone walls. Standing in the downtown courtyard at Mill and Main Streets, it attracted the close attention of thousands of people during the summer. Stonerside Stable sponsored the horse.

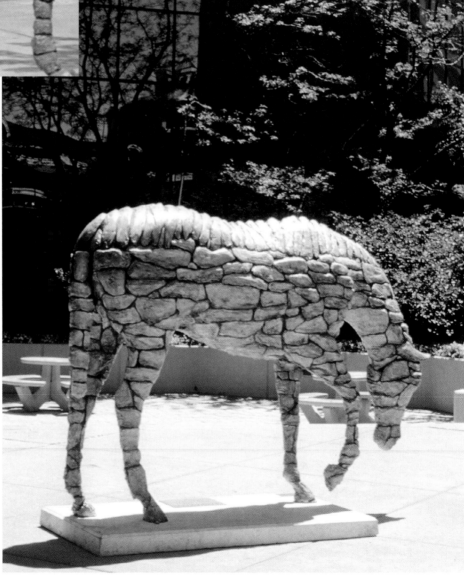

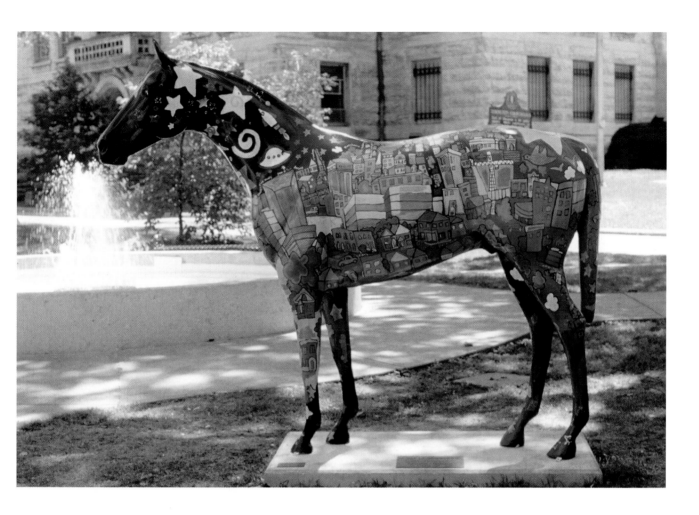

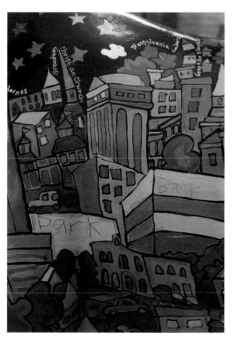

A Day in Downtown was a stylized graphic depiction of downtown Lexington, created by artist Pat Gerhard. The horse's body was covered with colorful views of downtown showing actual buildings. Standing near the old Courthouse at West Main and Cheapside Streets, the horse was sponsored by the Downtown Lexington Corporation.

Uranian Willy, located at West Main and Upper Streets, was the product of Lexington artist Clay Wainscott, who covered the horse with a plastic stencil and then used auto body spray paint to achieve an iridescent finish. Brown, Todd, & Heyburn, PLLC, was the sponsor.

Armored Horse was the striking creation of Lexington sculptor Penelope Whitman Mullinix, who clad the horse entirely in copper sheets, held on by thousands of tiny rivets. It stood in front of the old Courthouse, facing Main Street, and began during the summer to show the effects of the oxidation process that will eventually darken and enrich the colors of the metal covering. The Kentucky Thoroughbred Association was the sponsor.

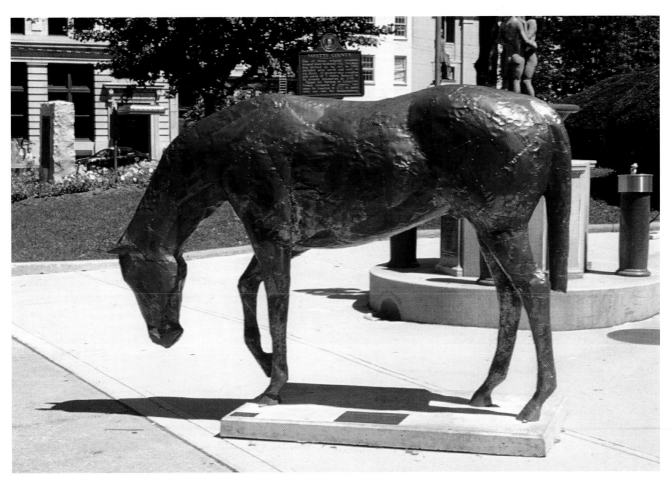

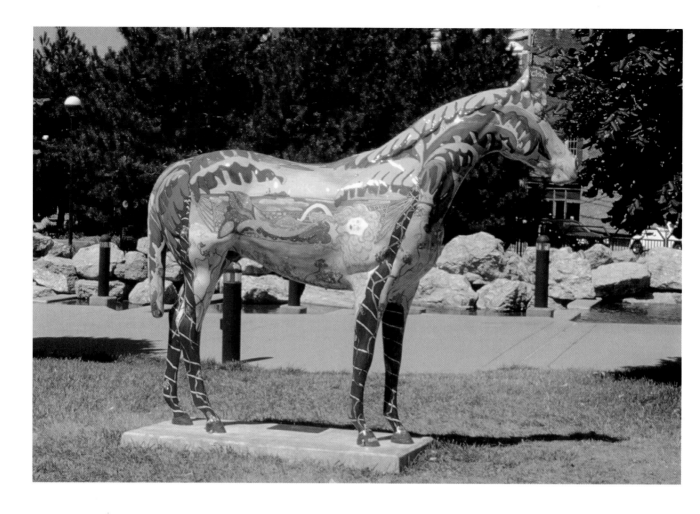

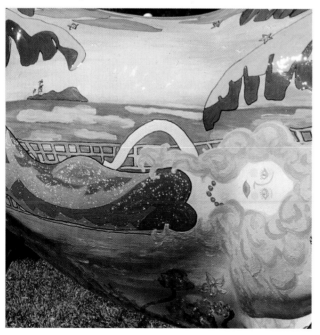

FantaSeaHorse by Lexington artist Mary Wathen evoked a vision of a mythical seashore with a colorful mermaid (resting in a hammock) and other fantastical sea creatures. Displayed prominently in Phoenix Park on Main Street, the horse was near the main offices of the sponsor, the Lexington Fayette Urban County Government.

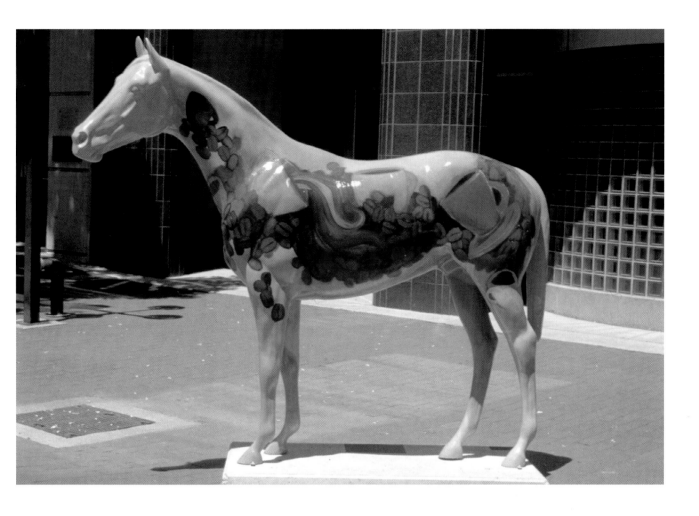

Stimulating by Louisville artist Jeaneen M. Barnhart was sponsored by john conti coffee co. and featured images of coffee beans and steaming cups of brew. It stood at the corner of Martin Luther King, Jr. Drive, looking out at the traffic that zipped by on Main Street.

Sweet Pea stood on Main Street across from Phoenix Park (next to a magnificent flying horse sculpture from Lexington's sister city in China). The riotously colored horse was created by Lexington artist Kim Sobel, who dripped paint on the surfaces to create a collage-like effect. It was sponsored by Bank One.

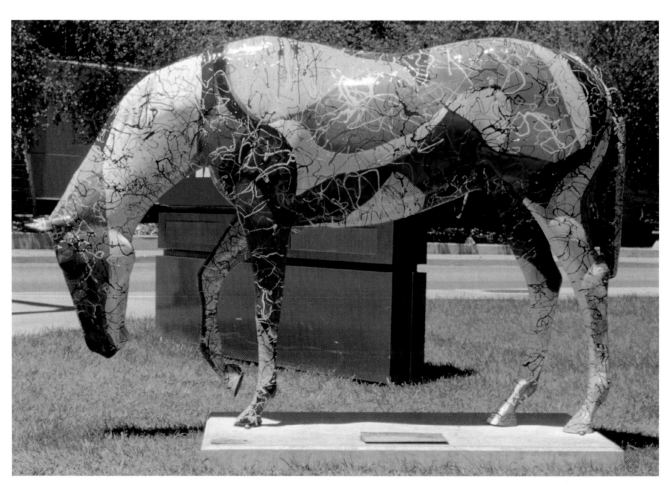

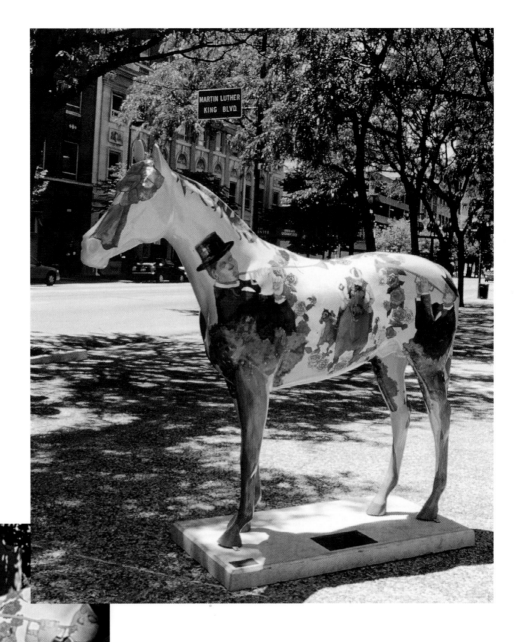

People's Delight by Cincinnati artist Velma J. Morris displayed a central horse racing scene, framed by two traditional track buglers, with other Kentucky symbols worked into the overall design. It was one of two horses in Bank One Plaza on Main Street. Stoll, Keenon & Park sponsored the horse.

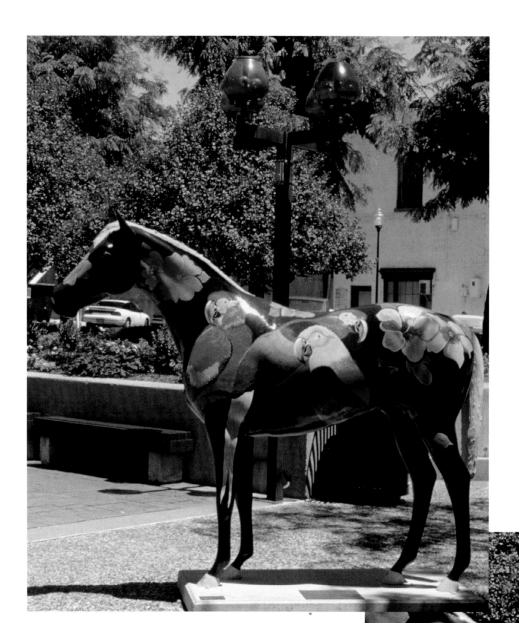

Kentucky is Horse Parrot-dize was named by Whitesburg artist Anna Daniel Hall as a pun incorporating both a reference to the horse's central images — colorful tropical parrots — and the fact that Kentucky is a paradise for horses. It stood in busy Bank One Plaza on Main Street and was sponsored by Lane Consultants.

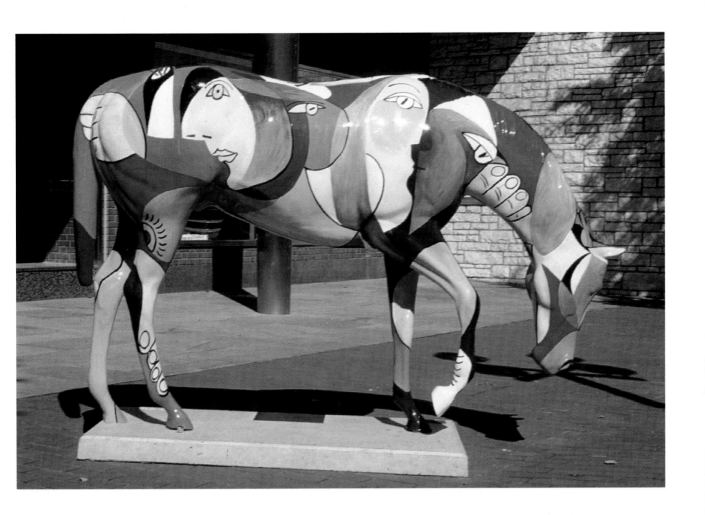

Pablo was painted by Lexington artist and teacher Lucinda Alston Chapman as a tribute to Spanish painter Pablo Picasso, probably the most famous artist of the twentieth century. She used images from Picasso's paintings in bold sizes. Revelers severely damaged the horse one late August night, but it was redone by the artist. It was sponsored by Gray Construction Company and stood at the firm's front door on Main Street.

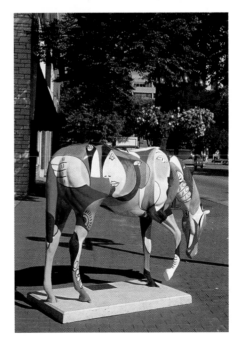

Manga Horse was a collage of fragments of Japanese comic books (a very popular form of literature in Japan, known as "Manga") by Lexington artist Louis Zoellar Bickett II. It was sponsored by Jim Gray and located at the corner of Vine and Quality Streets.

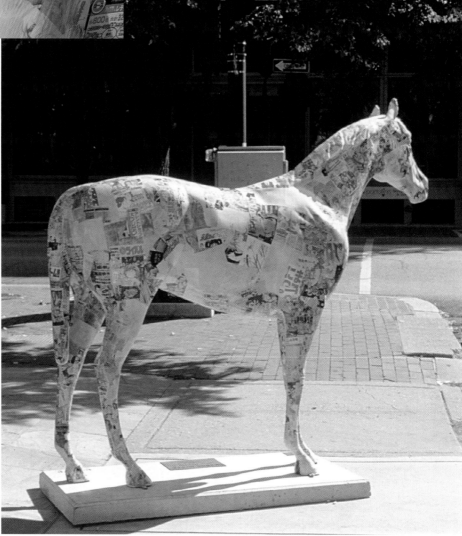

Rainbow Rider by Lexington artist Robert Morgan was one of the most physically and stylistically complex horses, intended as a commentary on weather and the natural elements. Its surface was thick with decoration and attached found objects. Sponsored by Kentucky Utilities, the horse stood on the corner of Vine and Quality Streets.

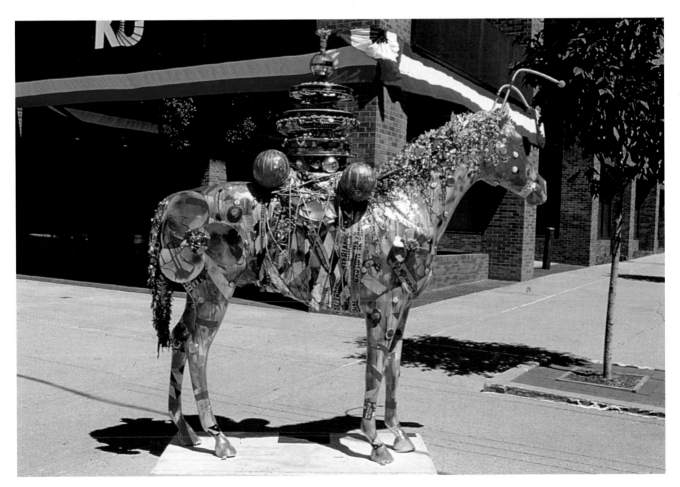

Pooka Dot by Raellyn Hatter, an art student at the University of Kentucky, was a very bright creation of overlapping polka dots in all sizes and colors. It was located in the front yard of the Beck House (L. Edwin Paulson), its sponsor, on East High Street.

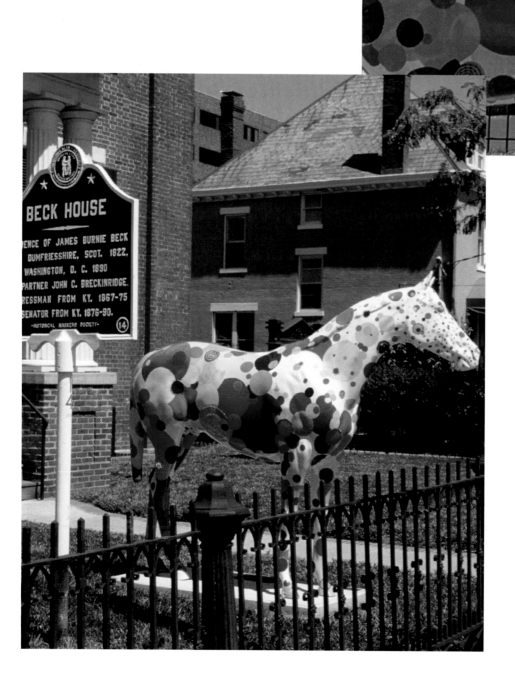

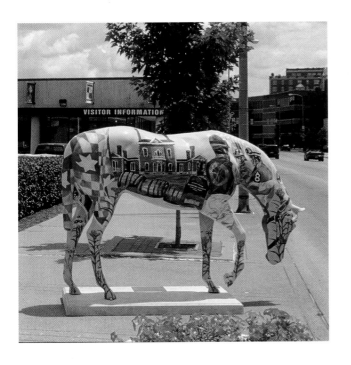

Uniquely Bluegrass was, in effect, a three-dimensional tourist poster that featured scenes of Bluegrass attractions on both sides. It was painted by Lexington artist Patricia SuzOnne Hall and co-sponsored by Cornett Advertising and the Lexington Convention and Visitor's Bureau. It was located near the Visitor's Bureau at Rose and Vine Streets.

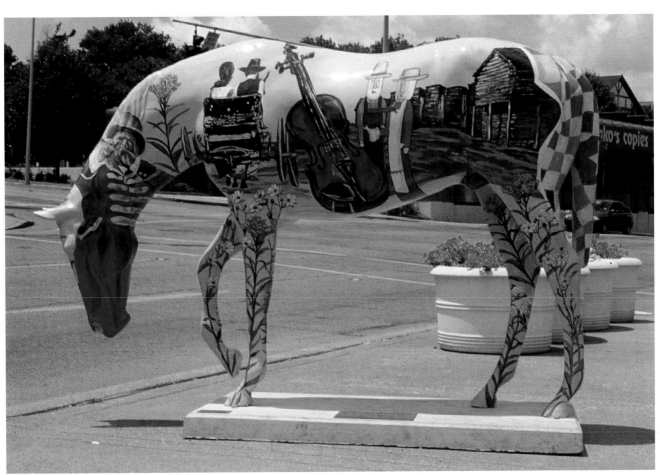

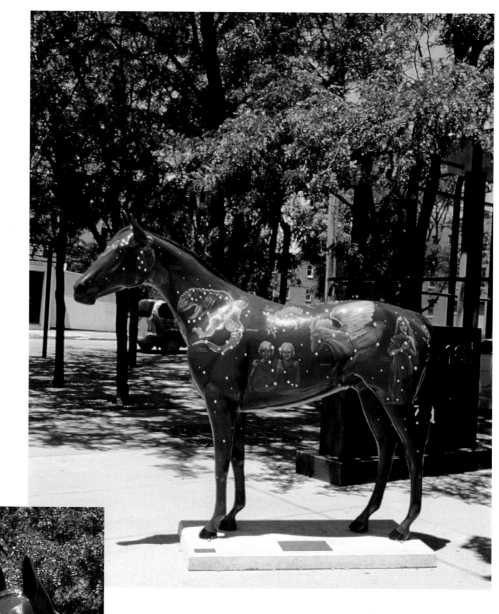

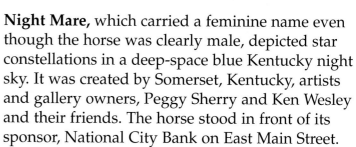

Night Mare, which carried a feminine name even though the horse was clearly male, depicted star constellations in a deep-space blue Kentucky night sky. It was created by Somerset, Kentucky, artists and gallery owners, Peggy Sherry and Ken Wesley and their friends. The horse stood in front of its sponsor, National City Bank on East Main Street.

Lily Mo-Neigh, one of many horses named with puns, depicted huge water lillies (and dragonflies) in the style of famous French artist Claude Monet. Lexington artist Ann R. Pass created the horse, which was located on East Main Street and sponsored by Omar and Nancy Trevino.

Lexington Thunder began as a horse, but became a bison, commissioned by sponsor Buffalo Trace Distillery and executed by Lexington artist Adalin Wichman (who also did an art horse for the Keeneland Association, see p. 70). The bison stood near Thoroughbred Park on Main Street.

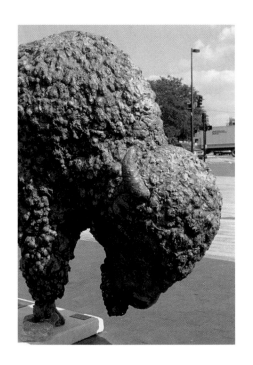

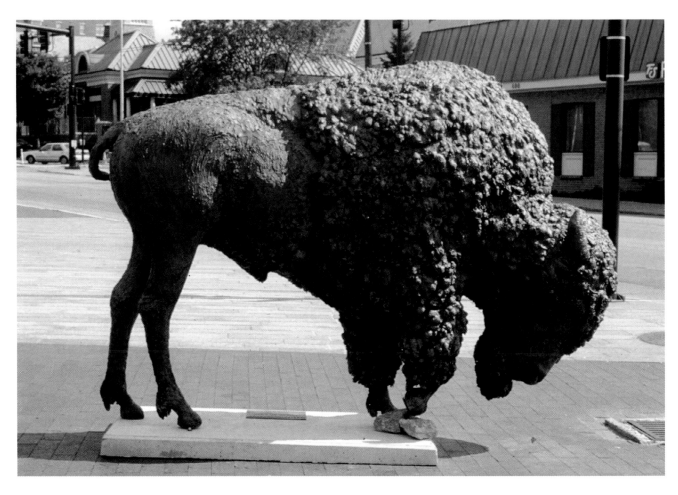

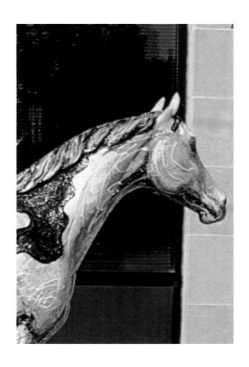

Apollo's Paint by Robert Tharsing, who teaches art at the University of Kentucky, was painted with an unusual technique that included using a mica-impregnated paint that looked like metallic glitter. It occupied a spot on the sidewalk along East Main Street near the doorway of the sponsor Tate.Hill.Jacobs.Architects.

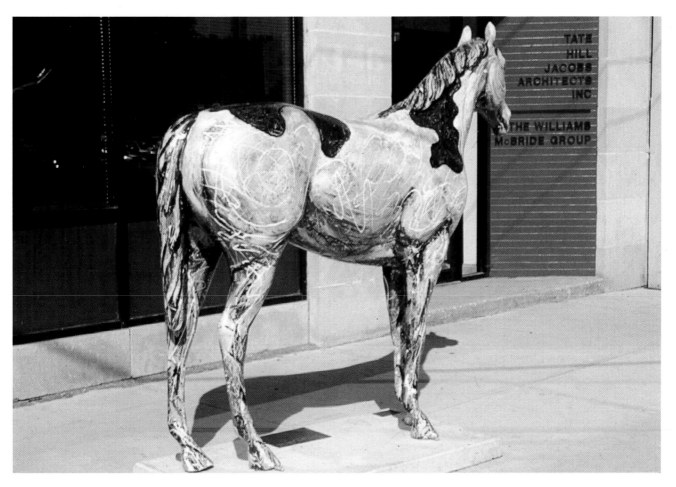

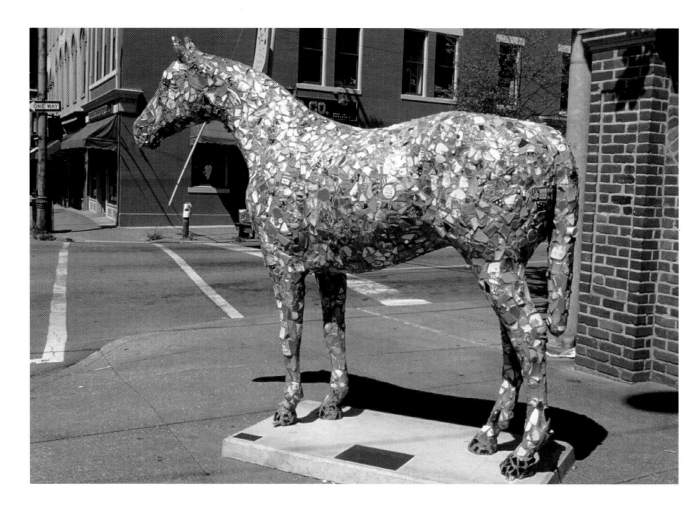

Caballo de Gaudi was a mosaic horse, covered with a variety of small objects such as china, jewelry, medals, and coins. It was designed by Louisville artist Jacque Parsley as a tribute to the Spanish architect Gaudi. "Gaudi's Horse" stood on a busy downtown corner near the Opera House at Broadway and West Short Street, inviting passersby to touch the rich surface texture. It was sponsored by the H. Greg Goodman Family.

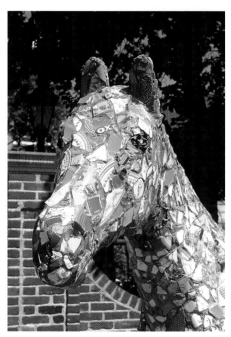

The Horse that Jumped over the Fence by Lexington artist Lawrence X. Tarpey took up most of a narrow sidewalk along downtown North Mill Street and was one of the most enigmatic of the art horses. It featured amoeba-like creatures on an air-brushed background surrounded by white-scratched figures. Equus Unlimited, Inc. and Standardbred Station, Inc. were the sponsors.

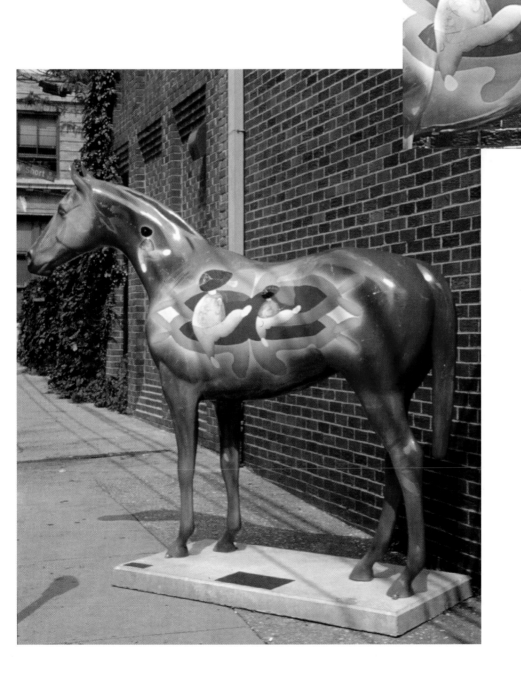

Carol's Birthday (Little Enis) by Lexington artist Georgia A. Henkel featured an effigy of eccentric musician Little Enis with a row of semi-nude Barbie dolls, representing dancers from the topless bars where Enis performed. When displayed on North Broadway, the dolls proved irresistible to vandals, and the horse was wheeled indoors at night. Paul and Carol Kaplan were sponsors.

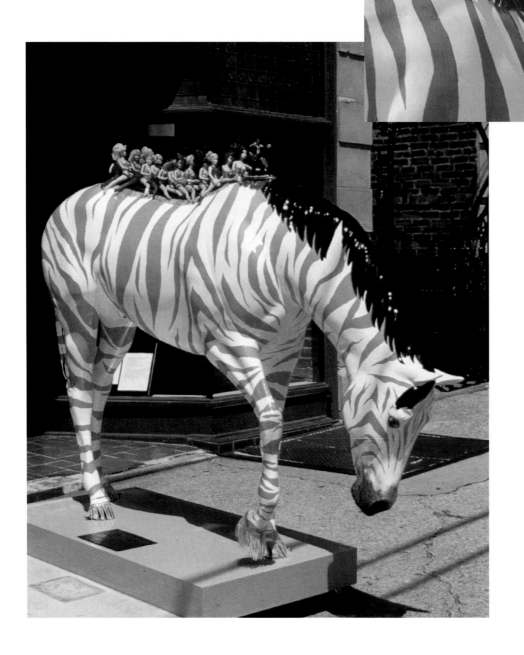

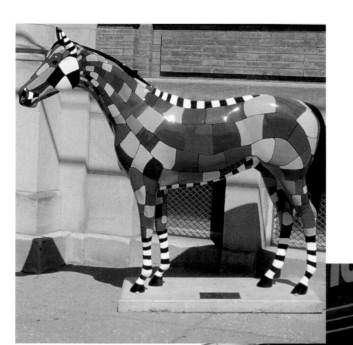

Mo (short for "mosaic") was painted by Lexington collage artist Carleton Wing as the prototype for all the Horse Mania horses and sparked a tremendous enthusiasm for the project among potential sponsors who were given a preview peek. During the summer, Mo guarded the front door of ArtsPlace, the headquarters of its sponsor, the Lexington Arts & Cultural Council.

Kentucky Blue Sky Horse by Lexington artist Karen Spears, who teaches art at Eastern Kentucky University, featured a deep-blue sky with puffy white clouds, reminiscent of a beautiful Bluegrass day. It stood just at the entrance to the offices of Nancy Barron & Associates, the sponsor.

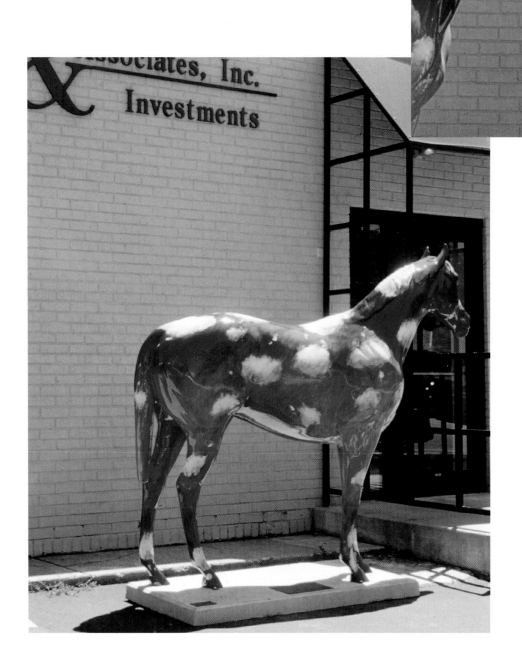

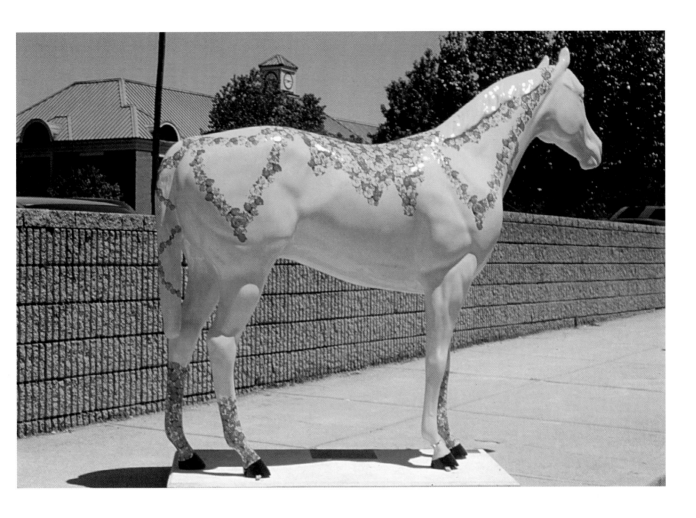

A Jewel in the Crown by Lexington designers Richard Kimbrel and Thomas Birkman was commissioned by sponsor Claiborne Farm and featured the farm's racing yellow with a rose wreath, referring to the Kentucky Derby, and hundreds of tiny mirrors. The horse stood on Grand Boulevard at Vine Street.

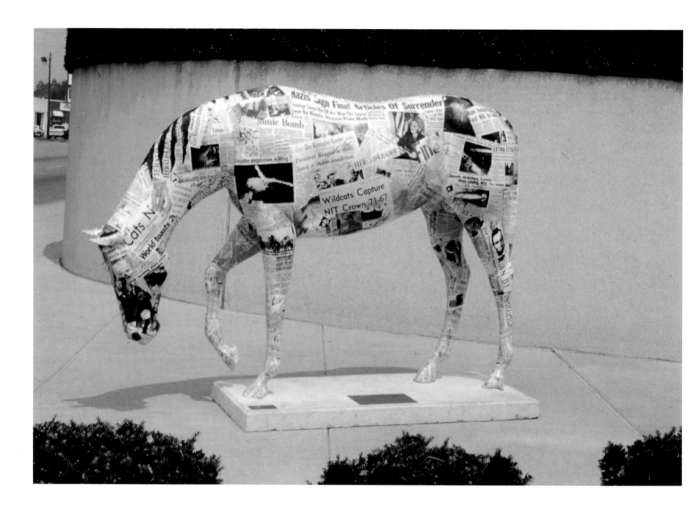

Herald "Scoop" Leader embodied Central Kentucky history with a pasted-on collage of decades worth of news stories from the *Lexington Herald-Leader*. The horse was prepared by eight artists on the newspaper's staff, led by Marianna MacDonald, and was stationed at the front door of the *Herald-Leader* building at Midland and Main Streets.

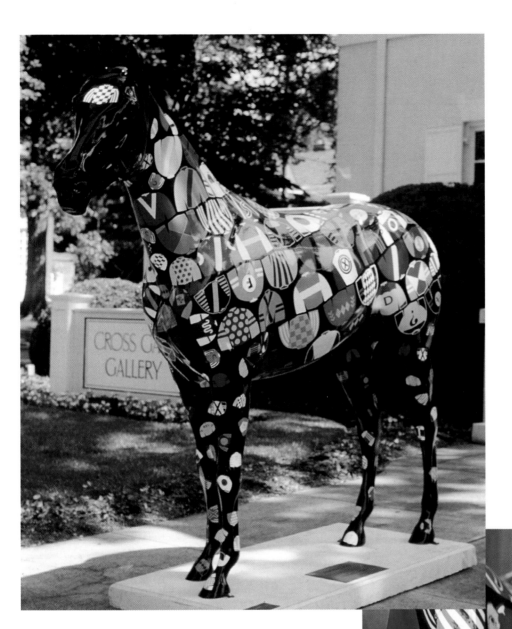

Jacques (a pun on "jock-keys") by artist John Cox sported dozens of racing silks, including all of the fifty most recent Kentucky Derby winners. Sponsored by Thorough-Graphic Signs, Inc., the horse stood most of the summer on Main Street in front of Cross Gate Gallery, but during July it traveled to Saratoga, New York, where it was on display for the racing season there.

Mirrored Horse, a brilliant conception by mother-daughter artists Hunter Guyon and Chesney Turner, was a head-to-hoof mosaic of mirror fragments, which reflected the horse's surroundings, the sky, and the viewer. "Mirrored Horse" was voted by readers of the *Lexington Herald-Leader* as the most popular of all Horse Mania horses. It stood in the front yard of Good Shepherd Episcopal Church on Main Street, and was sponsored by George Van Meter, Jr.

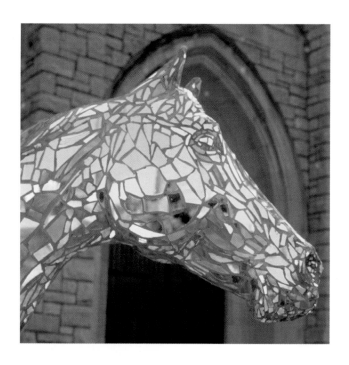

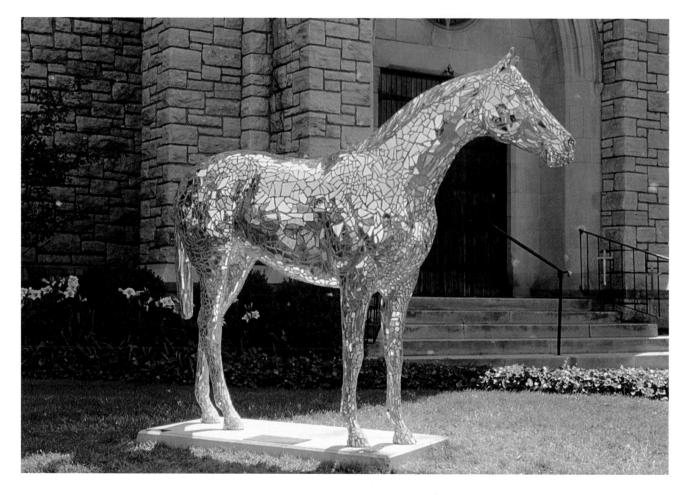

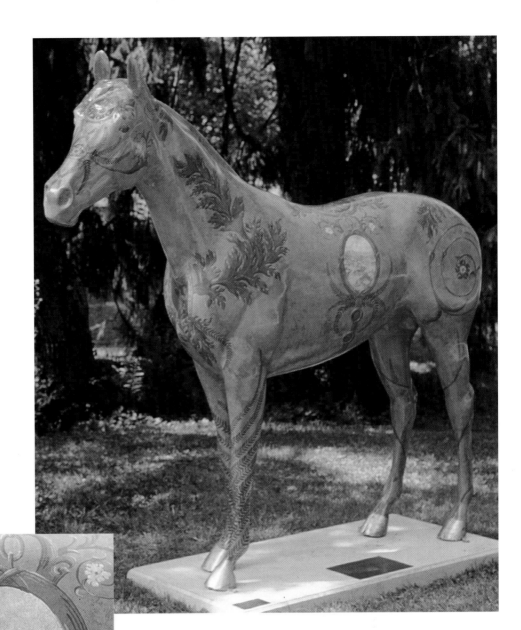

Trigger De Medici was a faux wooden horse that featured Renaissance-style central views of the Italian city of Florence. Its creator, Louisville interior design artist James E. Hurst, specializes in murals and faux finishes. The horse, sponsored by W.T. Young, was beautifully situated at a shaded corner of the Ashland estate on Richmond Road.

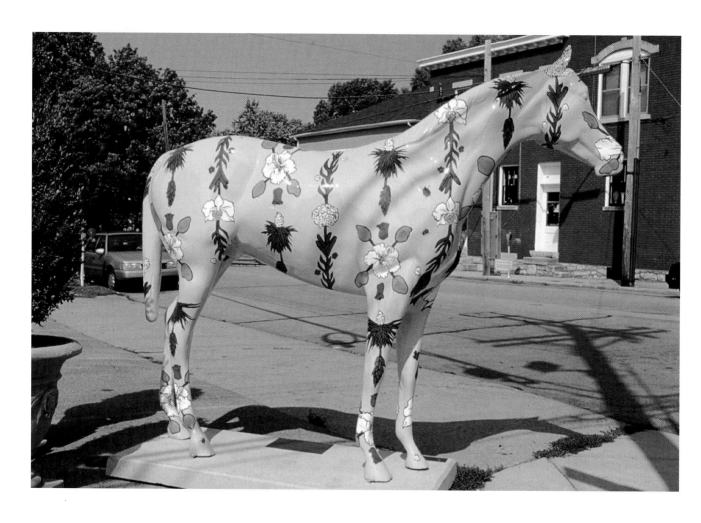

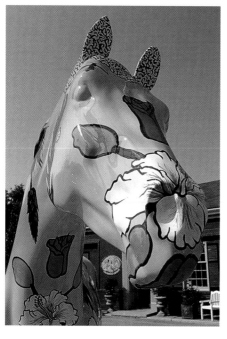

Tomas by Elizabeth Mesa-Gaido, who teaches at Morehead State University, was covered with flowers, vines, and other plants, all of which obliquely referred to one of the artist's young relatives. The horse stood at Clay Avenue and East Main Street and was sponsored by the Reinhold Group.

Not So Plain Joe, the creation of Lexington artists Lucy Slone Myers and Anne Bates Allen, was encrusted from head to hoof in sequins, beads, and costume jewelry, which created a rich surface texture that seemed to cry out to viewers to "touch me!" It was located on an expanse of lawn in front of Kentucky-American Water Company (the sponsor) looking out at the traffic on Richmond Road.

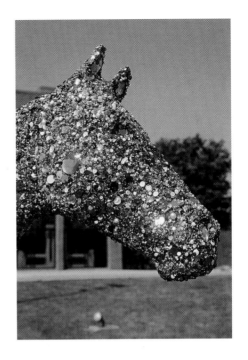

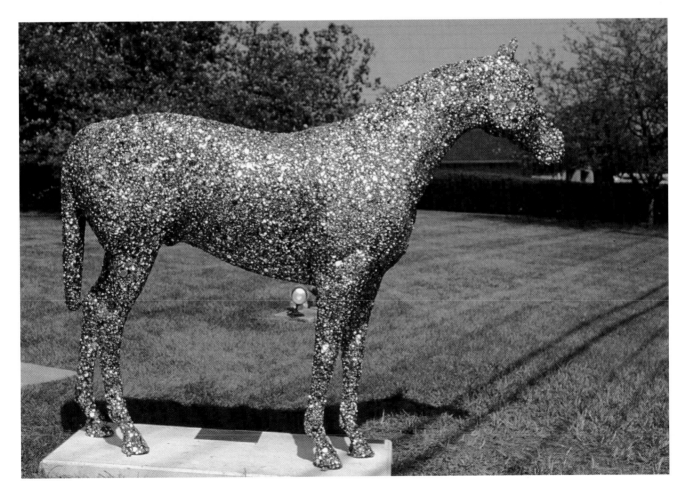

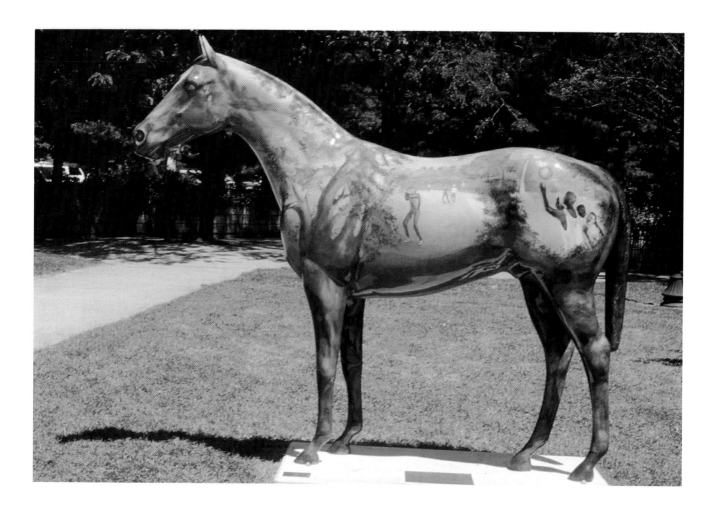

Park Horse, standing appropriately at the entrance to Woodland Park on East High Street, was painted by artist Gwen Reardon with recreational scenes from the park: softball, basketball, kids on swings, dogs being walked, tennis, jogging, and skateboarding. Alex G. Campbell, Jr. was the sponsor.

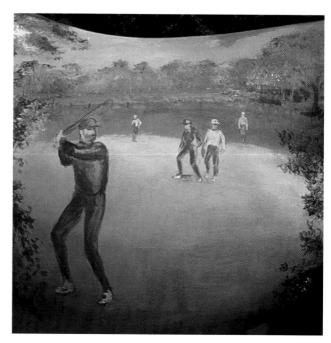

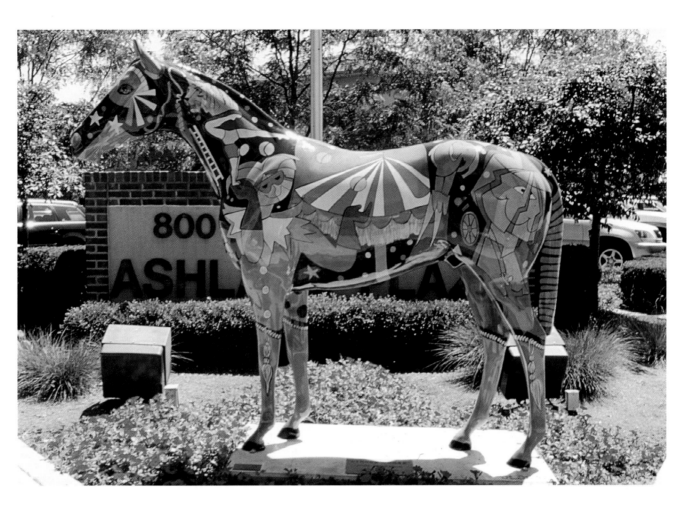

Circus Horse was adorned with large, boldly painted images of the circus, including the big top, clowns, acrobats, aerialists, and a tiger. The work of Cincinnati artist Judy Anderson (who also painted a pig for the Cincinnati public art "Pig Gig"), the horse occupied a busy corner at East High Street and South Ashland Avenue and was sponsored by Caller Properties.

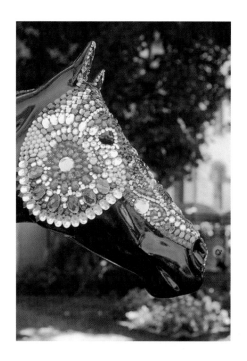

Caribbe by Lexington artist Lynda C. Hoff was a striking combination of a black body background and highly colored sequin-like jeweled designs, based on Caribbean symbols and images. The horse was at the corner in front of the Dudley Square building at Mill and Maxwell Streets. Mr. and Mrs. D. Greathouse were co-sponsors with Glencrest Farm.

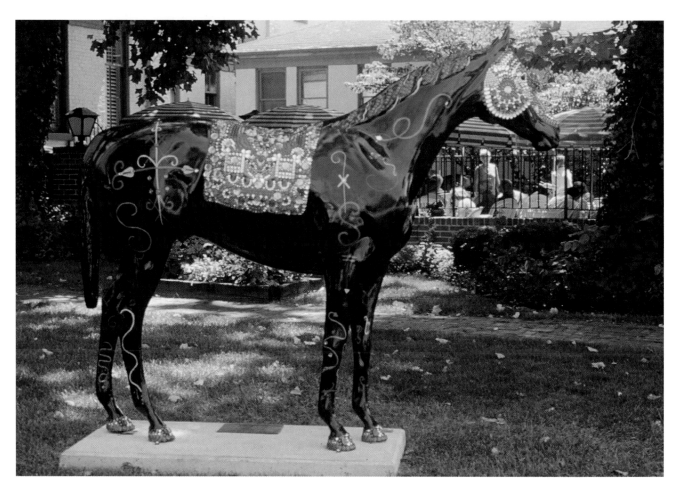

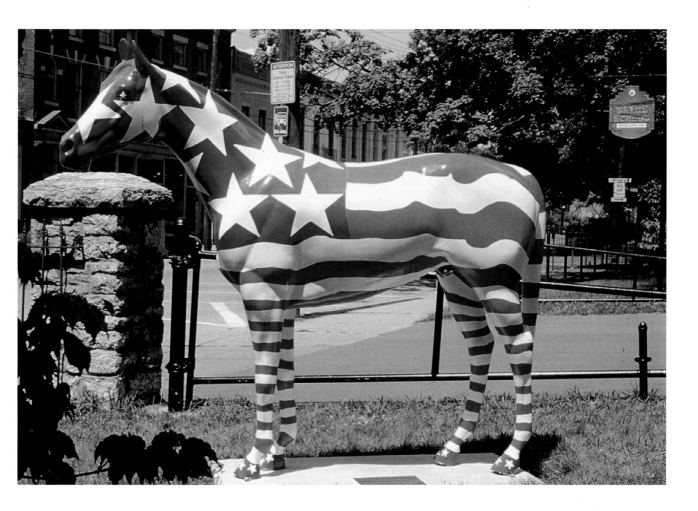

Flag self-evidently embodied its name, with a big, bold rendering of the U.S. flag stretching from nose to tail. It looked over the fence near the entrance to sponsor Sayre School on North Limestone Street. Bill Berryman, who teaches art at the school, painted the horse with help from his high school students.

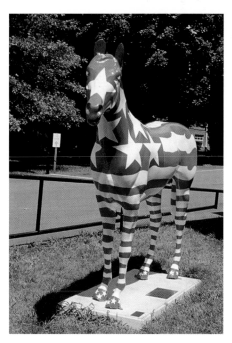

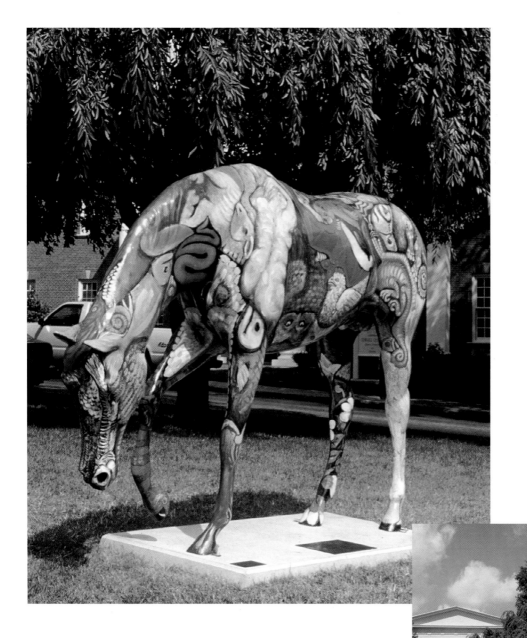

Community by Transylvania University art teacher Dan Selter was a beautifully rendered painting of intertwined animal and human shapes. More and more figures emerged from the painting the longer a viewer looked. The horse, sponsored by Mr. and Mrs. James H. Frazier, stood in front of Transylvania's Old Morrison, looking across Third Street toward Gratz Park.

Horse & Garden, located on busy North Broadway in front of sponsor Treasure Isles, Inc., was decorated by Lexington artist Nuchi Cain with all manner of garden plants and creatures, including day lilies, irises, frogs, butterflies, and many more. The horse challenged viewers to discover all its images.

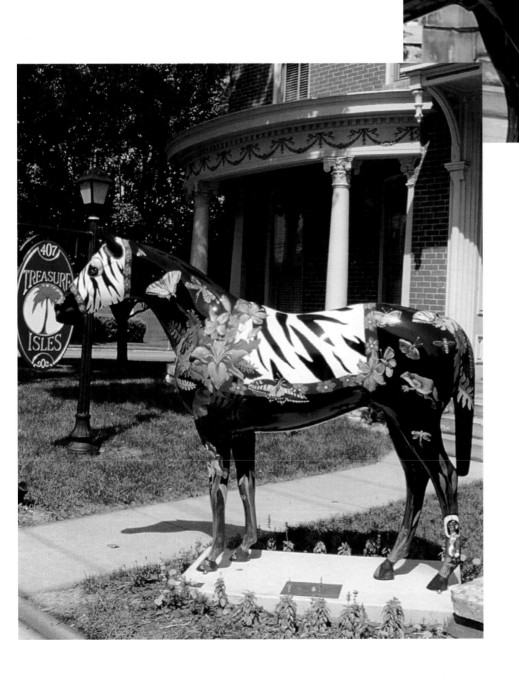

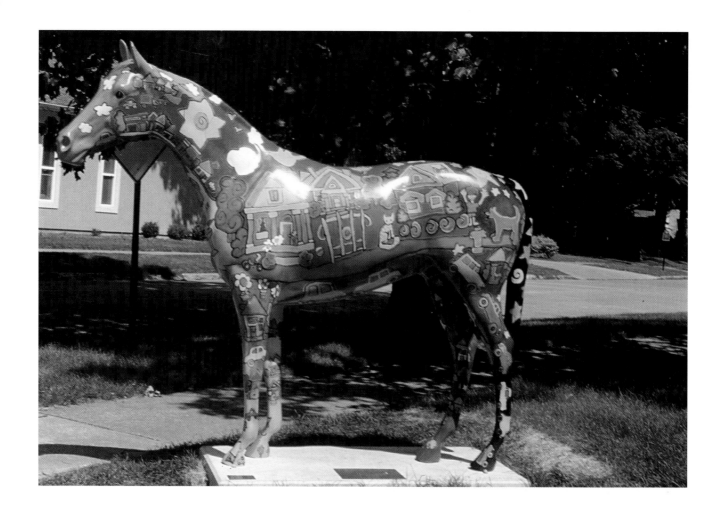

Historic Neigh-borhood was another colorful depiction of buildings by artist Pat Gerhard (see also "A Day in Downtown," p. 27). The painting showed the neighborhood around its location at Elsmere Park and North Broadway and was sponsored by ELF Partners.

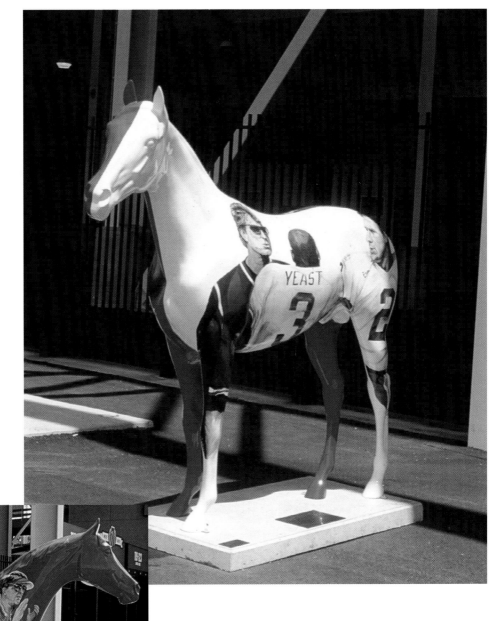

Katfandu by Nancy Evans Nardiello (see also "Galloping Gourmet," p. 10) celebrated the fans of the University of Kentucky and their beloved football Wildcats. Celebrity quarterback Tim Couch visited and autographed the horse, which guarded the entrance to Commonwealth Stadium. Sue and Brown Badgett, Jr. were the sponsors.

Barn Scape, which stood in front the Singletary Center (the sponsor) on the campus of the University of Kentucky, was the work of artist and UK professor Robert James Foose and depicted the black tobacco barns and four-board fences typical of the Central Kentucky landscape.

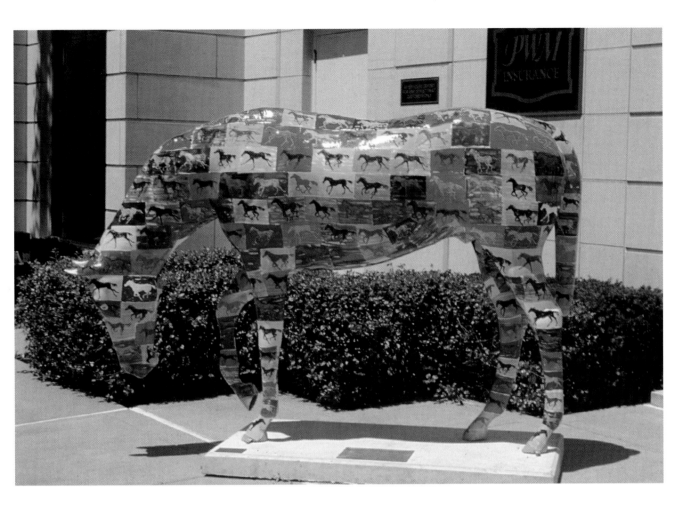

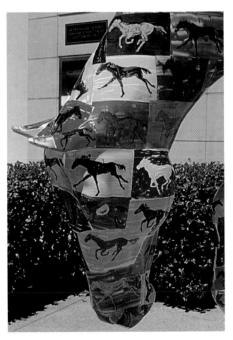

Skewbald the Racing Horse by artist Patrick Despeaux of Bloomfield, Kentucky, was covered with multi-colored rectangular panels that showed a horse galloping in a variety of configurations, reminiscent of the famous horse-motion pictures by photographic pioneer Eadweard Muybridge. The horse was sponsored by Vine Street Trust and E.S. Barr & Co. and was located on East Vine.

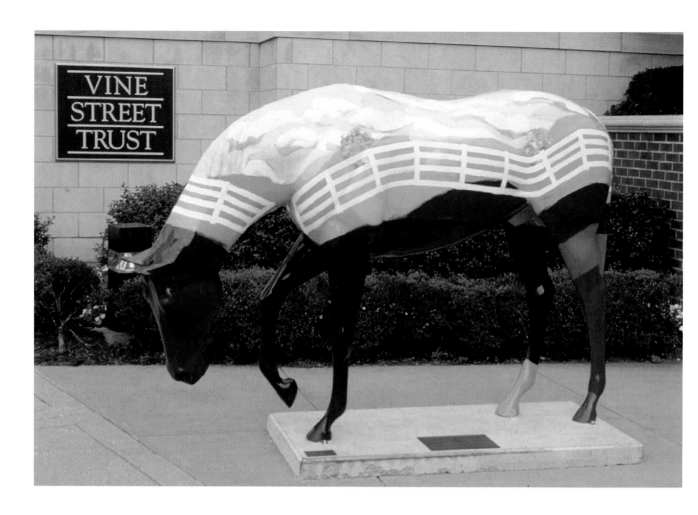

Landscape by University of Kentucky art teacher Robert James Foose was a companion piece to his "Barn Scape" (on p. 64) and featured the classic elements of the Bluegrass countryside: rolling pastures and board fences. The horse was on East Vine near the office of its sponsor, Powell-Walton-Milward.

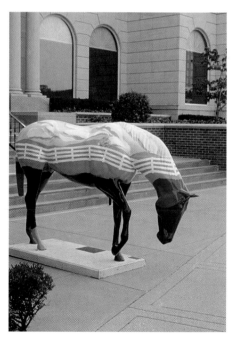

Isaac Murphy's Last Ride was a powerful and complex artistic statement about race and racism by University of Kentucky professor Gary Bibbs and featured striking symbols and images. It was damaged soon after going into place near the Swahili Elks Lodge on New Circle Road and was absent for several weeks for repairs. The African American Forum was the sponsor.

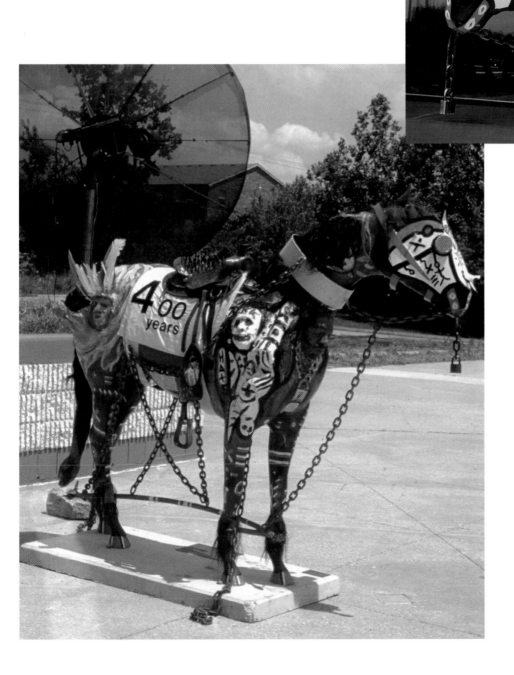

Horse Shoes by Holly VanMeter, who lives in Winchester, Kentucky, was yet another horse named with double meaning. It was covered with dozens of colorful paintings of women's shoes. The horse, sponsored by Breeder's Supply, Pinkston's Turf Goods, Inc., and R. E. Fennell Company, began the summer at the entrance to the Red Mile, but moved to two subsequent locations on West High Street.

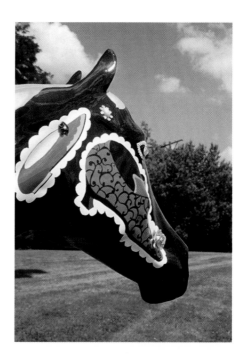

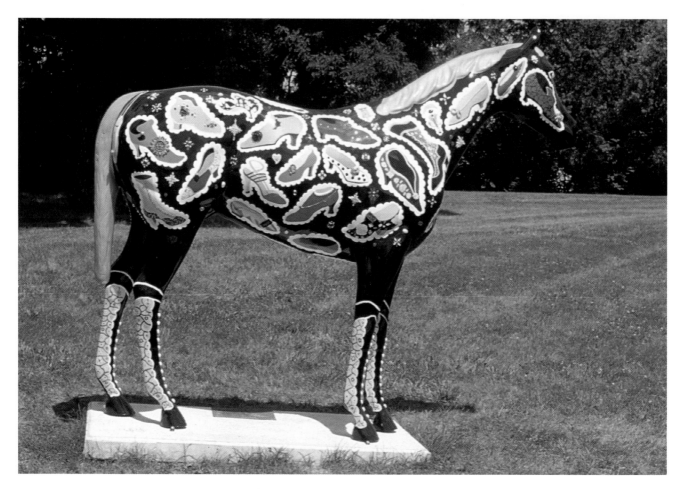

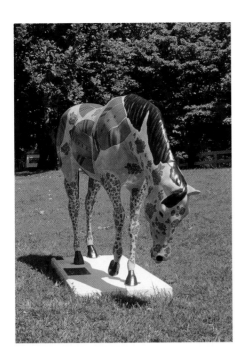

Bull Lea was a creature of Calumet Farm, the sponsor, and not only carried the farm's racing colors (along with a Derby rose motif) but was named for one of its famous horses, the sire of Citation. The creation of Tess Larimore, "Bull Lea" was strategically sited at the entrance to Calumet Farm on Versailles Road, just outside Lexington.

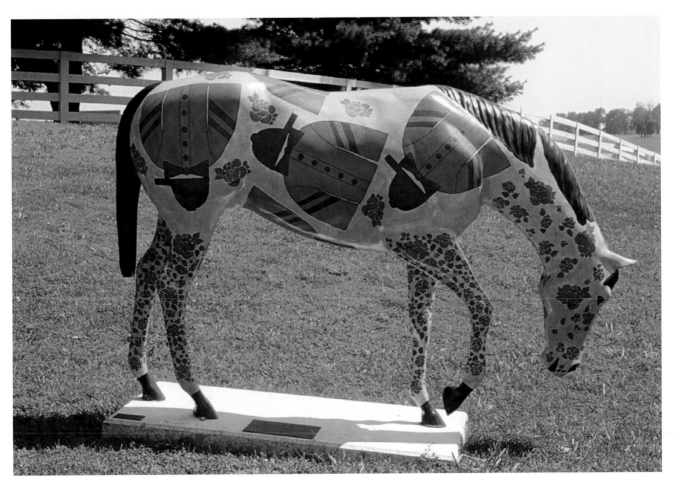

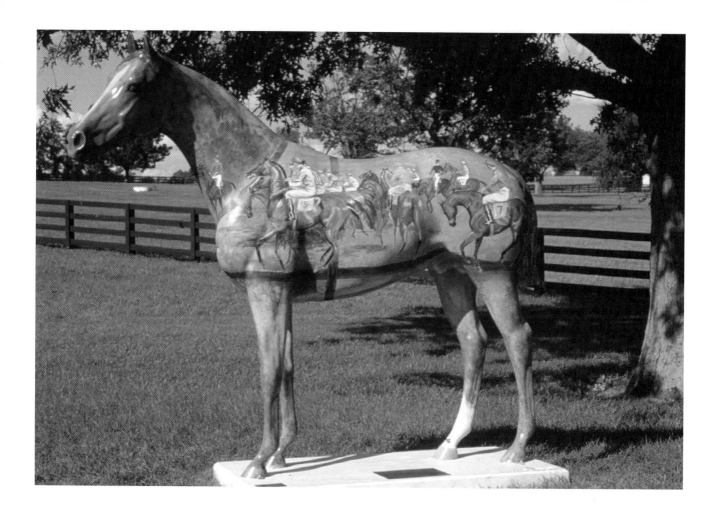

Impressionist by Lexington equine artist Adalin Wichman (see also p. 42) had a beautiful site: just inside the Man o' War Road entrance to Keeneland. The horse depicted racing scenes as painted by nineteenth century French impressionist painters. Wichman sawed off the original tail to mimic a race horse. Keeneland Association, Inc. was the sponsor. The horse was stolen in September but was soon recovered from a nearby field.

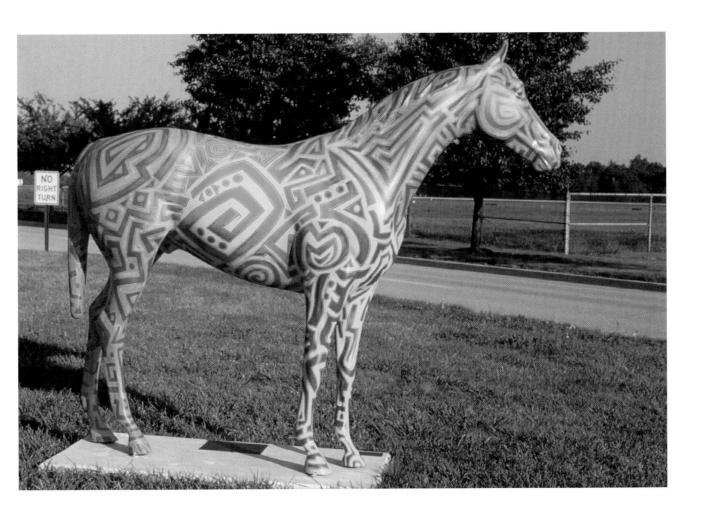

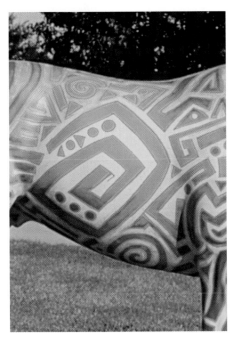

Tribal by Louisville artist John E. Mahorney stood at the entrance to Blue Grass Airport, its sponsor, and was a rendering of the artist's version of universal tribal designs. The result was an explosion of color and pattern.

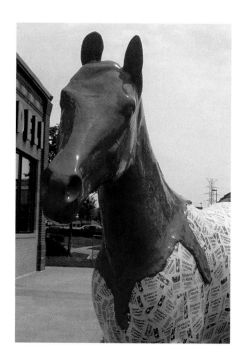

"Get on your mark . . . Get set . . . Go" by Nancy Durham of Crestwood, Kentucky, celebrated Maker's Mark whiskey. The body of the horse was plastered with Maker's Mark labels and the head appeared to have been dipped into the whiskey maker's trademark red wax. It stood outside the Beaumont Center store of its sponsor, The Liquor Barn — The Ultimate Party Source.

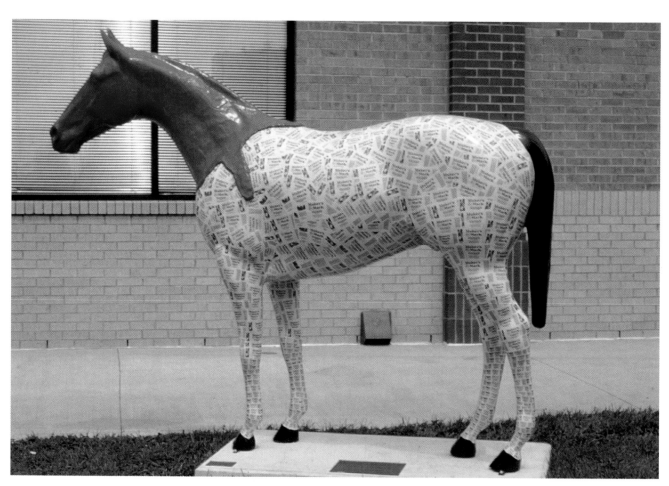

Lost in the Rain Forest was the highly imaginative creation of Cissy Hamilton and Ronna Love, two art teachers at the Lexington School, which sponsored the horse and where it was placed for display. The horse featured not only a toucan perched on its back, but a serpent crawling up a foreleg and other creatures peering from the lush foliage.

The Quilted Horse by Harlan County artist Larry May was covered in beautiful painted quilt squares, many of them in classical quilting patterns. The bucolic patchwork design contrasted with the horse's location next to the bustling drive-in lane of the horse's sponsor, the MacDonald's restaurant on busy Harrodsburg Road.

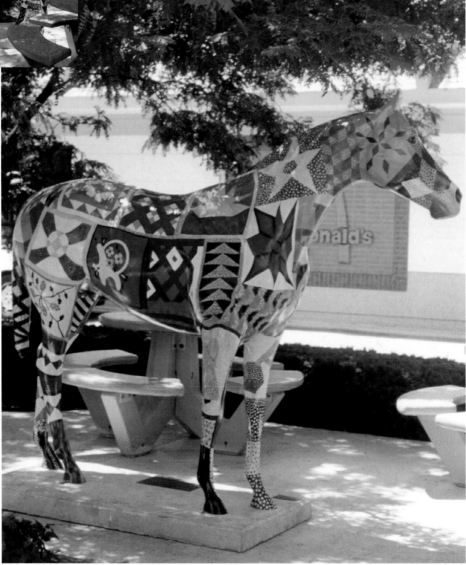

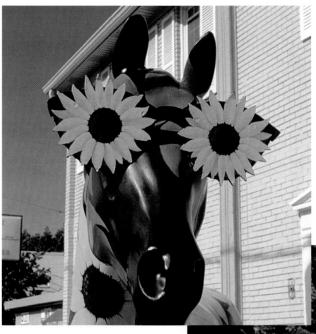

Black-Eyed Susan by Lexington art director Melody Moore was one of the most whimsically charming horses. Perched next to the constant rush of traffic on Nicholasville Road, the horse sported huge Black-eyed Susan sunglasses that brought a smile to viewers' faces. Physicians Eye Center, PSC was the sponsor.

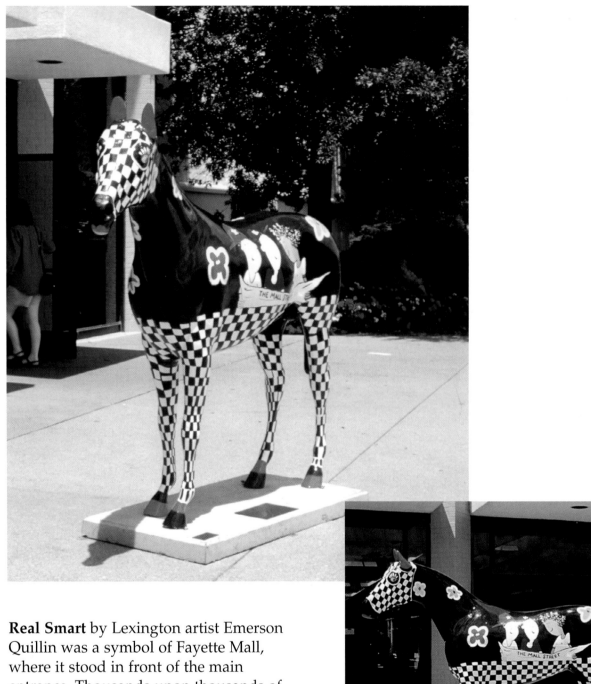

Real Smart by Lexington artist Emerson Quillin was a symbol of Fayette Mall, where it stood in front of the main entrance. Thousands upon thousands of mall customers passed by the horse, which featured mall themes, each day. Some just detoured around; others stopped to look, touch, and photograph. The Fayette Mall Merchants Association was the sponsor.

Old Gray Mare by Louisville artists Brad and Laura Devlin was a delight for fans of monochromatic art. It was covered in sheets of lead that were varied slightly in color and textured to produce a patchwork study in subtle tonal values. The horse was located on the sidewalk in front of the Lexington Green store of sponsor Tempur-Pedic, Inc.

Moondancer was an actual mosaic, covered with small pieces of porcelain and stoneware tiles that were arranged into surface patterns. Artist John R. Guenther of Borden, Indiana, created the horse with a differing design on each side, evoking the visible and the dark sides of the moon. It stood on Richmond Road, in front of sponsor Powertel.

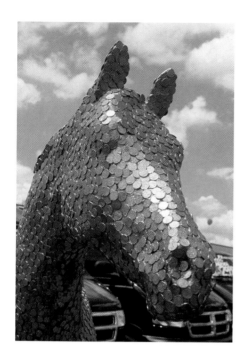

Horse Cents, yet another horse named with a play on words, was entirely encrusted with genuine U.S. copper pennies by Lexington artist Kim Comstock. The horse was sponsored by Freedom Dodge and was located near the entrance to the car dealership on New Circle Road.

Prism Philly was painted as a brooding Bluegrass landscape in dark colors by Lexington artist C. Philip Willett, but it also featured an unusual opalescent surface that gave the horse an entirely different aspect depending on the light conditions. It was sponsored by Quantrell Cadillac and stood in front of the dealer's showroom on New Circle Road.

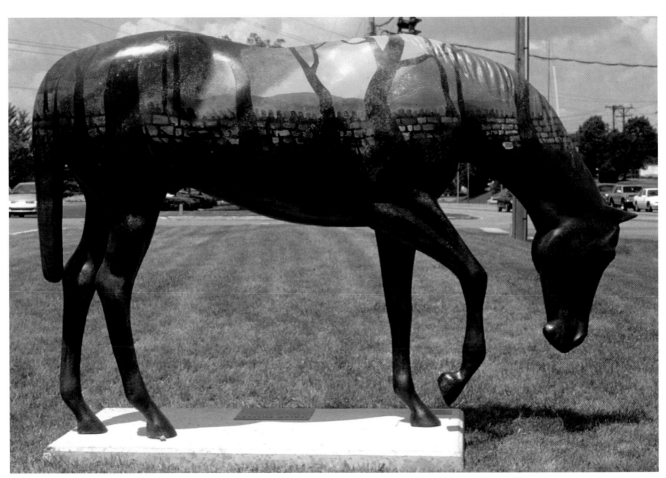

Sea Horse by Susan Sturgill of Columbus, Ohio, was a beautiful creation made out of applied vinyl on a painted background, featuring sea creatures such as a jelly fish, an octopus, crabs, and seahorses. It was in a difficult location for pedestrians, between busy New Circle Road and a thick hedge, near the office of its sponsor, the International Plastics Group.

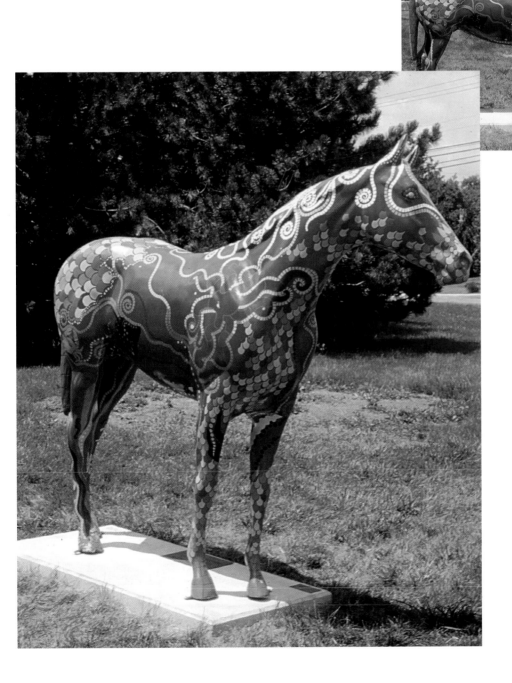

Part of the Landscape, the product of Lexington artist K.M. Johnson, was a typical Bluegrass landscape, painted in shades of green, as seen from a field, including a creek, a fence, and a road. It was located only a few feet from traffic on New Circle Road in front of the showroom of sponsor Brock-McVey Company.

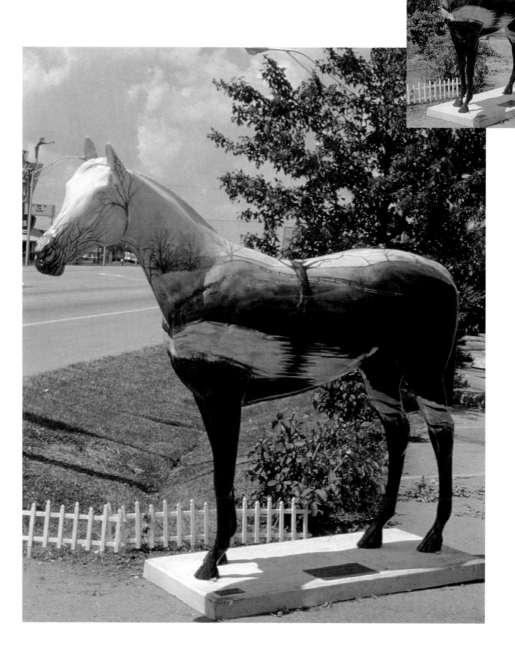

Definition Symbol by Lexington artist Mary Ashley Miller had a stark white background on which were painted a variety of universal symbols, such as those for love, success, AIDS awareness, the "spirit of the moon," and many more. Viewers were supplied with a typewritten key to the symbols. The horse was in front of sponsor Paul Miller Ford on New Circle Road.

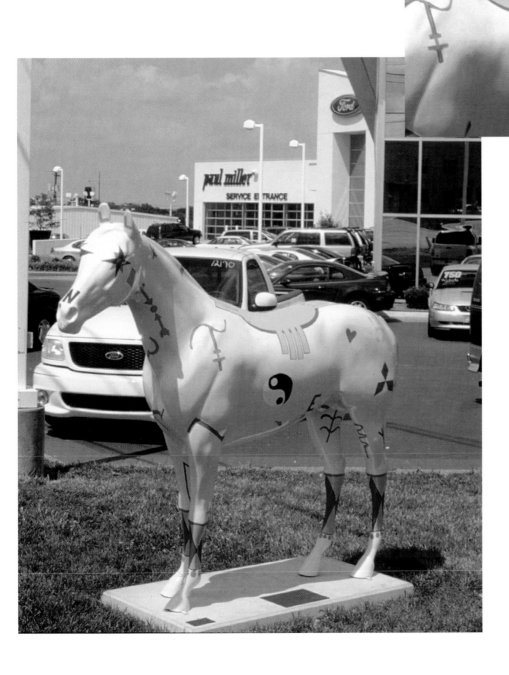

Color Bars stood guard over the entrance to sponsor WKYT-TV's studio and offices on Winchester Road. The horse was designed by Lexingtonian Martha Chute and incorporated the color bars that are broadcast by the television station during off hours (the spectrum allows you to fine tune your set's color balance).

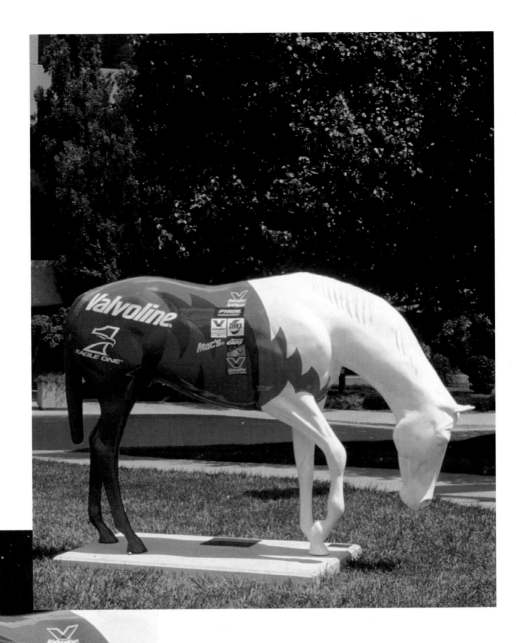

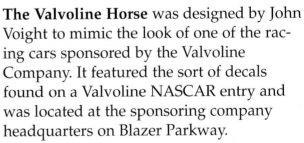

The Valvoline Horse was designed by John Voight to mimic the look of one of the racing cars sponsored by the Valvoline Company. It featured the sort of decals found on a Valvoline NASCAR entry and was located at the sponsoring company headquarters on Blazer Parkway.

Paint-By-Number Horse would have allowed any of us to become Horse Mania artists by just filling in the familiar numbered panels as instructed. Lexington artist Becky Simmermacher showed her sense of humor in this horse, sponsored by John Van Meter and located at the home of the Lexington Art League in Castlewood Park.

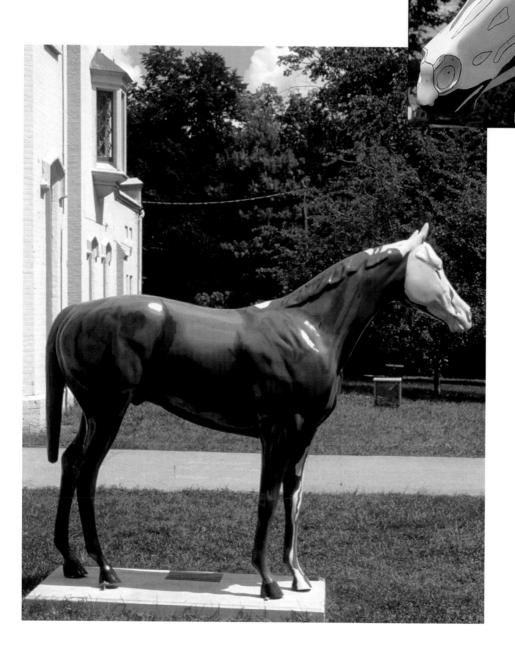

Behind the Scenes

Horse Mania grew from the desire of the Lexington Arts & Cultural Council to create a public art program that would put high-quality art on display for the enjoyment and benefit of everyone in the community.

"Public art," said LACC's Executive Director Dee Fizdale, "contributes to the enjoyment of your surroundings and gives you pride in your city."

The LACC had seen evidence of what such a public art project could accomplish by looking at Chicago's "Cows on Parade." However, the natural choice for Lexington — the self-proclaimed "Horse Capital of the World" — was not the franchised cow idea, which had originated in Switzerland, but rather the thoroughbred horse with its natural elegance that would lend itself to sophisticated art instead of caricature.

At least twenty-two other cities launched similar art projects during the summer of 2000, ranging from pigs in Cincinnati to "Mr. Potato Head" in Rhode Island.

Under the leadership of Steve Grossman, Chair of the LACC Horse Mania steering committee, the LACC planned the project both to benefit community charities and to create a long-term public art fund for Lexington. Sponsors selected a horse design and contributed $3,700 to cover the cost of the fiberglass model and provide a fee for the artists. At the end of the exhibit, the horses were auctioned off, with the proceeds split after covering the LACC's expenses between a charity chosen by the sponsor and the public art fund. With start-up underwriting from the Kentucky Thoroughbred Association, the project was launched.

The initial task was to find a fiberglass horse model. The first company contacted demanded an impossible fee to design a mold, but after a bit of Internet research, the steering committee found a company in Nebraska that already manufactured a suitable thoroughbred model at a reasonable price. Moreover, the maker was willing to modify the mold to produce two versions, one standing and one grazing.

The LACC ordered a single sample fiberglass horse and turned it over to Lexington collage artist Carleton Wing, with a commission to create a prototype decorated horse that could be used as a graphic example and demonstration of what Horse Mania would be all about.

The next step was to find enough artists who were qualified and had the necessary vision to create the sophisticated horses the LACC wanted. The LACC put out a wide-ranging call for designs, reaching beyond Lexington to Louisville and into Indiana and Ohio. Artists were asked to

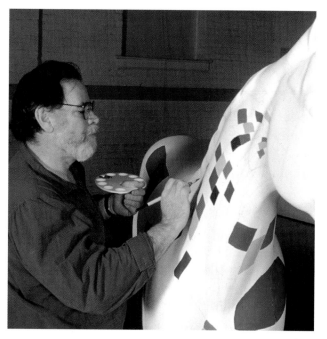

Carleton Wing designed and painted "Mo," the prototype horse.

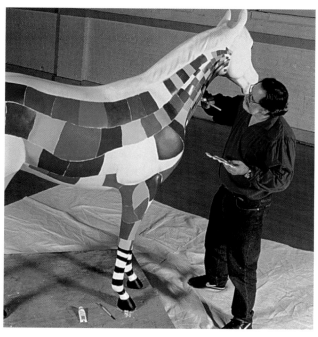

The horse contours were a challenge to paint.

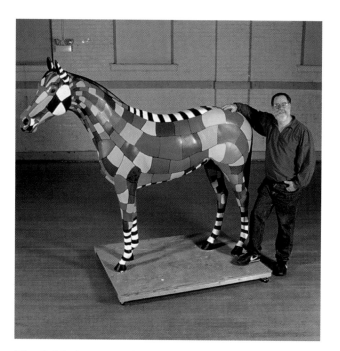

The finished version of "Mo" inspired many sponsors to step forward.

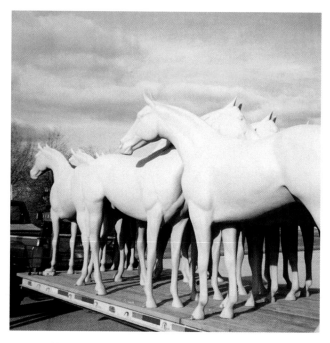

The naked fiberglass horses arrive from Nebraska.

submit a description and a sample (if appropriate) along with a resume. More than 200 artists responded with a total of 600 design submissions, which were then reviewed by a jury of gallery owners, artists, and museum curators, who culled the number down to 90.

Meanwhile, several members of the steering committee worked the local networks hard to solicit sponsors, who were asked at this stage to respond to an idea and to sign up sight unseen. Within weeks, fifty sponsors were on board, but the solicitation slowed at that point.

Happily, Carleton Wing's prototype horse "Mo" was nearing completion, and when prospective sponsors saw the colorful statue, they were usually sold on the idea. In March, "Mo" moved out of ArtsPlace, where Wing had worked, and was shown off at a news conference and then put on temporary display in Triangle Park. Sponsor recruiting soared in response.

The next stage was to match sponsors and artists. Over a two-day period, sponsors came to ArtsPlace and looked over the available design submissions and made their selections. A few sponsors commissioned horses directly from artists they chose themselves, but their designs also went through the jury process.

When shipments of blank horses arrived, artists were called to a warehouse on Mercer Road and told to bring a truck and tie-downs. The first confrontation of some of the artists with their horses was a bit overwhelming as the practical challenges of dealing with a full-size thoroughbred replica became apparent, but they took away their steeds and went to work.

Not every artist had a studio space big enough to handle the horses, so many were painted or decorated outdoors or in garages. Some artists moved aside their furniture and worked in their living rooms. Several horses were crowded into the large studio at Artists' Attic. Within weeks, however, the horses were finished and gathered again at the warehouse. After a "coming out" party at the warehouse, where sponsors were invited to meet their horses, the stage was set for the horses to go public.

The logistics of siting and installing seventy-nine fiberglass horses were challenging, but with the generous help of community volunteers the work was carried out with dispatch. Concrete pallets were made for each horse along with name plaques, and the pallets were transported and installed with heavy equipment, waiting for the horses.

At 5:30 p.m. on June 28, ninety volunteers from six local construction companies began the process of loading the horses at the warehouse dock and moving them to their respective sites. At nearly the same time all across the city, horses were set in place and secured to their pallets. By 7:30 p.m., Horse Mania was a reality, and as the early summer shadows lengthened, people began to mill around the horses in Triangle Park, forming the vanguard of thousands upon thousands of admirers to come.

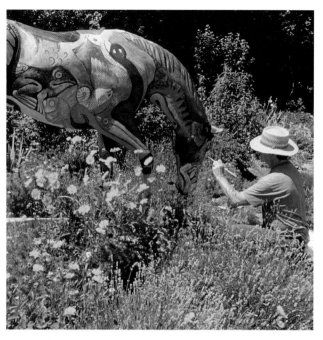

Dan Selter worked on "Community" outside in his yard.

Several artists painted horses in the Artists' Attic.

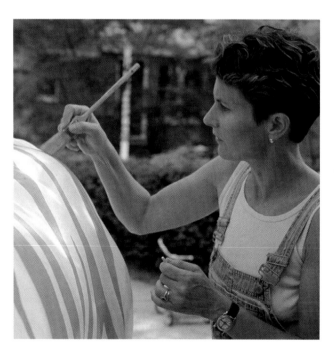

Georgia Henkel and "Carol's Birthday/Little Enis."

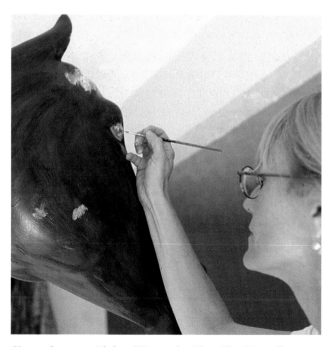

Karen Spears with her "Kentucky Blue Sky Horse."

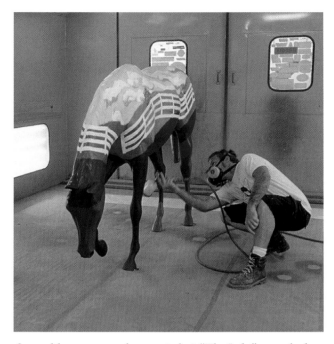

Several horses were clear-coated at "The Lab," a car body shop.

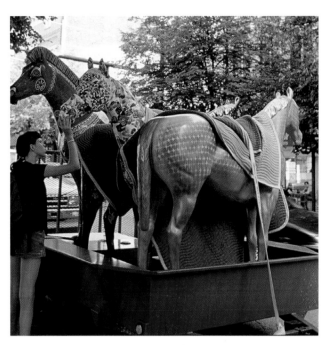

The finished horses were moved from the warehouse for installation.

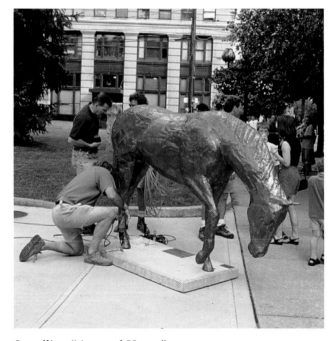

Installing "Armored Horse."

A Colt Joins the Herd

Late in September, too late to be photographed for this book, a charming colt named "Blue Glass" joined the Lexington Horse Mania herd. The baby horse statue was decorated by Louisville artist Stephen Ingram Barnes, who applied a mosaic of deep blue glass to the colt's surface. It was displayed inside ArtsPlace and raffled for charity at the Horse Mania auction in December.

About the Lexington Arts & Cultural Council

Mission: The Lexington Arts & Cultural Council Promotes
Excellence in and Enjoyment of the Arts in Central Kentucky.

Formed in July 1989 by the merger of the Lexington Council of the Arts (founded in 1972) and the Fund for the Arts (founded in 1984), the Lexington Arts & Cultural Council has worked for the development of a strong arts community as a means of enhancing the lives of the people who live and work in central Kentucky. The LACC serves sixty active, associate, and affiliate member organizations, individual artists, and the community-at-large. Through its annual campaign, the LACC provides operating funds to thirteen beneficiary organizations as well as grant support for community outreach projects and equipment. Since 1985, the Council has raised in excess of $11 million in support of local arts. Member organizations of the LACC reach more than 840,000 people each year.

Paramount among the Council's functions is its role as liaison between Lexington arts organizations and local and state government. A wide range of assistance is provided to arts groups and artists. Since 1972, public awareness of area cultural offerings has been enhanced by information services such as ArtScene and, lately, through the Council's website: www.lexarts.org.

The Council manages ArtsPlace, a community arts center in downtown Lexington. A 1904 Beaux Arts Classical building, ArtsPlace houses arts organization offices, dance studios, rehearsal space, and a gallery. In the fall of 2001, at the request of local government, the Council will manage the new Downtown Arts Center. Gallery Hop, a major downtown event involving simultaneous openings of more than twenty commercial and not-for-profit galleries, has been coordinated by the LACC since the early 1990s. Like Horse Mania, Gallery Hop is a valuable component in downtown revitalization.

Horse Mania represents a culmination of the Council's advocacy efforts for public art in Lexington and its first public art project.

Horse Mania Steering Committe

Stephen L. Grossman, Chair, Hilliard Lyons
Dee Fizdale, Lexington Arts & Cultural Council
Glenn Leveridge, Bank One
Becky L. Reinhold, The Reinhold Group
David L. Switzer, Kentucky Thoroughbred Association
Ann Tower, Tower Cerlan Gallery

Horse Mania Jury

Ann Tower, Chair, Tower Cerlan Gallery
Greg Ladd, Cross Gate Gallery
Robert Morgan, Artist
Rachael Sadinsky, University of Kentucky Art Museum
Nancy Wolsk, Transylvania University Division of Fine Arts

Lexington Arts & Cultural Council
Board of Directors & Staff 1999–2000

Executive Committee
Stephen L. Grossman, Chair, Hilliard Lyons
Janet A. Craig, Chair-Elect, Stites & Harbison
Kathy Plomin, Vice-Chair, Campaign, WKYT-TV
James E. Lee, Jr., Vice-Chair, Allocations
Samuel G. Barnes, Secretary, Fifth Third Bank
Melissa A. Wasson, Treasurer, Pricewaterhouse Coopers
Chauncey S. R. Curtz, Chair, Long Range Planning, Big Sand Management Co.
Deb Shoss, Chair, Member Groups Committee, Actors' Guild of Lexington
Roger M. Dalton, Past-Chair
Dee Fizdale, Lexington Arts & Cultural Council

Directors
Paula Anderson, Lexington Herald-Leader
Mark C. Boison, Bank One
Marilyn G. Clark, WLEX-TV Channel 18
Peggy Collins, Community Volunteer
Roger R. Cowden, Kentucky Utilities
Richard S. DeCamp, Lexington Fayette Urban County Council
Gayle M. Dorio, Community Volunteer
Robert C. Douglass, Greater Lexington Chamber of Commerce
Barbara B. Edelman, Dinsmore and Shohl
Ray F. Garman, M.D.
Judge Pamela R. Goodwine
Ed G. Lane, Lane Consultants
Denise McClelland, Frost & Jacobs
Paul E. McLynch, Dillard's
Frank Mauro, Lafayette Club
Rick Music, Valvoline Company
Thomas A. Poskin, PNC Advisors
Keith Rector, Rector-Hayden Realtors
Sharon Reed, Community Volunteer
Betty Reynolds, GTE Operator Services
David W. Richard, Dean, Dorton & Ford
Harry T. Richart III, National City Bank
Robert Shay, University of Kentucky College of Fine Arts
Bruce Smith, Marriott's Griffin Gate Resort
Roberta Steen, Toyota Motor Manufacturing
Stephen W. Switzer, Greenebaum, Doll & McDonald
Bob Tober, IBM
Mary Wathen, Mayor's Office
Janice Wells, Central Bank & Trust Co.
Sandy Wensley, Kentucky Medical News
Bud Willis, J. C. Bradford & Co.

Staff
Sarah Burdette, Staff Assistant
Terri DeAtley, Building Manager/Program Coordinator
Dee Fizdale, Executive Director
Lesley Gwynn, Marketing and Event Coordinator
Dani Luckett, Development Coordinator
Karla Totty, Staff Assistant

Horse Mania Underwriter

Kentucky Thoroughbred Association, Inc.

Horse Mania In-kind Contributors

Accuprint, Inc.
Atchison Construction — Kyle Whalan
Brett Construction — W.T. Setzer
Brill Construction — Mike Brill
Buffalo Trace
Alex Campbell
Georgann Chenault
Cloud Concrete Products
Cornett Advertising
Crawford Builders — Mac Crawford
Dapple Companies
Frantz, Inc.
Frost & Jacobs
Hartston, Inc.
Hilliard Lyons
International Plastics, Jim Turek
Andrew Jones
Keeneland Association
Kentucky Arts Council
kentucky.com
Kwik-Set Fasteners, Inc.
Lab Auto Body, Steve Green
Lexington Cemetary
Lexington Convention & Visitors Bureau
Lexington Children's Theatre
Lexington Fayette Urban County Government
Lexington Remodelers Council
Lexington Trophy Company
Liquor Barn — The Ultimate Party Store
Louisville Visual Art Association
Kindred Homes — Laurence Kindred
Padgett Construction — Tom Padgett
Phase 4 Construction- Mike Andronix
M.S. Rezny Photography
The Rock Corp.
Saunier Moving & Storage
Saw Horse Construction — Peyton Roberts
Sawyer's
Seagram's
Stites & Harbison
Tempur-Pedic
Tenmast Software
Thorough-Graphic Sign Co.
Vimont Builders — Ted Vimont
Viper Link of the Bluegrass
Randy Walker Electric
Warner Companies
Webb Companies
Wilhite Limited, Inc.
Carleton Wing
W. T. Young, Sr.

Indexes

Index of Sponsors